IMAGES OF ASIA

The Chinese Garden

D0151446

TITLES IN THE SERIES

Series Editors, China Titles:

NIGEL CAMERON, SYLVIA FRASER-LU

The Chinese Garden

JOSEPH CHO WANG

HONG KONG
OXFORD UNIVERSITY PRESS
OXFORD NEW YORK
1998

Oxford University Press

Oxford New York
Athens Auckland Bangkok Bogota
Bombay Buenos Aires Calcutta Cape Town
Dar es Salaam Delhi Florence Hong Kong Istanbul
Karachi Kuala Lumpur Madras Madrid Melbourne
Mexico City Nairobi Paris Singapore
Taipei Tokyo Toronto

and associated companies in
Berlin Ibadan

Oxford is a trade mark of Oxford University Press

First published 1998
This impression (lowest digit)
1 3 5 7 9 10 8 6 4 2

Published in the United States
by Oxford University Press, New York

British Library Cataloguing in Publication Data
available

Library of Congress Cataloging-in-Publication Data

Wang, Joseph C.
The Chinese garden / Joseph Cho Wang.
p. cm. — (Images of Asia)
Includes bibliographical references (p.) and index.
ISBN 0-19-587586-9 (alk. paper)
1. Gardens, Chinese. I. Title. II. Series.
SB457.55.W37 1998
712'.0951 —dc21

Printed in Hong Kong
Published by Oxford University Press (China) Ltd
18/F Warwick House, Taikoo Place, 979 King's Road,
Quarry Bay, Hong Kong

Contents

Preface

This is a small book about a big subject: the Chinese garden. I hope you will share this sentiment when you have read through it. The garden in question, private or imperial, is not merely a pleasing man-made artefact adorned with a pond, rocks, buildings, and plants. It is a piece of art that reflects the ideals of its owner–designer, the joy and sorrow of its inhabitants, the vitality, tranquillity, and beauty of the earth, and its intertwining relationship with other art forms such as landscape painting, pastoral-style poetry, and literature. In a sense, in discussing the Chinese garden we are touching on the essence of Chinese history and culture.

In this book, a three-level approach to the study of Chinese classical gardens is used. First, an appreciation of the garden as a setting for the good life involves pragmatic concerns for bringing elements of nature into the home's extended 'living-room', where fresh air and sunlight are abundant, where guests are entertained and children play. Such a garden, reflective of the owner's appetite and appreciation for an artistic life, can be studied according to its level of comfort and visual beauty. Second, most Chinese gardens were inspired by natural landscapes and designed in the same manner as landscape paintings were created. Often, the owner–designer was an artist in his own right. The gardens in this category are the product of artistic endeavours and, as such, can be analyzed by a set of principles derived from art, which correspond to the syntactic (that is, concerning structure and organization) dimension of creative arts and design.

The third criterion is the semantic level, at which gardens reflect and embody the ideals of their creators or owners. The garden designer may strive to convey an ideal romance, a lifelong ambition (perhaps unfulfilled), an unyielding integrity, or wishes for a utopian world. The gardens in this category embody subtle, intangible ideas that are more commonly conveyed in poetry and paintings. Such attributes or meanings may not be easily interpreted and a full appreciation of the garden would require a high level of sophistication and scholarship on the part of the beholder. A thorough understanding of the historical and cultural background surrounding the development of the garden is a prerequisite for enjoying gardens of this type.

I hope by now that the orientation and emphasis of the book are clear to you. It is not my intention to produce yet another text on the subject to compete with, or duplicate the efforts of, those good but conventional publications already in print. Nor is the book meant to be a summary or an abridged version of books already published. I would, however, readily acknowledge their contributions and treat them either as prerequisites or as further readings to extend the understanding of the topic provided by my own writing. Curiously, the nature of my task does not allow me to use pictures and graphics in generous proportions. I have to rely primarily on words to communicate a subject matter which is largely visually oriented. Happily, this 'limitation' has turned out to be an asset rather than a handicap, because, in a small way, it offers me an opportunity to illustrate my contention that Chinese gardens can be enjoyed and appreciated beyond the visual and sensual dimensions. In this sense, this little work is a microcosm of my argument for an alternative way of looking at the Chinese garden. I hope this book will help the sincere garden lover to enjoy the garden's charm and

natural beauty, satisfy the inquisitive intellect in his or her quest for analysis and principles, and enhance the transcendental scholar's 'reading' of (the meanings of) the garden beyond its perceptual, physical forms.

Many friends and colleagues have offered their encouragement and assistance. In particular, I would like to thank Julie Kane for editing the text and Mengzhou Mac Liu for the design of the chronological chart. Professor Young-tsu Wong of the History Department at Virginia Tech untiringly served as my consultant whenever I was facing a missing link in Chinese history and culture. Two friends in Suzhou could always be relied upon: Professor Xu Dejia of the Suzhou Institute of Urban Construction and Environmental Protection provided much needed information on topics rarely appearing in published form, while Chief Landscape Architect Zhan Yongwei of the Suzhou Garden Bureau graciously shared his expertise in Suzhou gardens at all times.

My greatest debt is to Professor Cheng Liyao of China Architecture and Building Press, Beijing. Practically a 'walking encyclopedia' on the subject of Chinese gardens, he was only a fax machine away at anytime and throughout the entire process.

Joseph Cho Wang
Blacksburg, Virginia

1
Historical Development

THREE PRINCIPAL TYPES of gardens have evolved with the development of Chinese culture: imperial gardens and parks, private gardens, and natural scenic sites. Generally large in scale and lavishly equipped, imperial parks were built exclusively for the pleasure of the emperors and their families. Private gardens, also called literati gardens, were designed by or built for scholars who demanded simplicity, elegance, and poetic meaning in their personal worlds. Natural scenic sites were developed from larger areas of special character and beauty, often including monasteries as focal points. In contrast to Japanese temple gardens, most Chinese monasteries were located in places of unusual scenic beauty and so their monks were not compelled to develop additional gardens within the building complex (Cheng, 1995: 2). Taking as its subject the conceptualization and construction of the Chinese garden, this book will focus its examination on imperial parks and private gardens.

According to historical records, the first known hunting-ground for imperial pleasure, called *you*, existed during the late Shang dynasty (*c.*1600–*c.*1027 BC). Measuring up to 200 kilometres in length, this vast pleasure-ground was built on natural terrain and filled with exotic plants, animals, birds, and fish. The only man-made object in the hunting-ground was a tall, square earthen platform. It was said that the platform was the site where the emperor performed cosmic rituals, studied constellations, observed the weather, and enjoyed other recreational activities. Some six centuries later, the design of this earthen platform underwent significant changes. The size of the platform was dramatically

increased, and on top of it elaborate palace buildings were constructed to accommodate the merrymaking of emperors and their nobles. The *you* may be said to be the origin point for all the forms of Chinese imperial gardens that followed it.

The earliest mentions of imperial gardens, as we know them today, are found in records of the Qin (221–207 BC) and Han (206 BC–AD 220) dynasties. Qin Shihuangdi (r.221–210 BC), the first emperor of the Qin, began to have built a garden that he named the Shanglin Yuan *(yuan* is the Chinese word for garden or park) in the south of his capital city, Xianyang. Due to its vast scale and complexity, the garden construction was not complete when he died. Emperor Wudi (r.140–87 BC) of the Han dynasty continued the unfinished task, and it was thirty more years before the project was finally completed.

The Shanglin Yuan occupied an immense area of three hundred *li* in circumference (one Han *li* is about 400 metres). During the Qin era alone, more than three hundred palaces were built in the garden. Within its boundary, there were animals and plants of all sorts, large forests, and man-made lakes. The Kunming Hu (*hu* means lake in Chinese), covering an area of 300 hectares, was the most famous and the largest of the lakes. It was said to be used extensively for pleasure boating at that time. The lake also served as a naval training ground, as well as a reservoir for urban dwellings. The enormity of the park and the rich natural resources it contained have prompted speculation that economy was also a prime motivation for its creation. A prominent scholar has theorized recently that mining, forest and animal husbandry, and farming in the Shanglin Yuan helped to meet expenses, while the park's amenities satisfied the desires of the emperors for pleasure and sport (Zhang, 1986: 50–1).

The literary descriptions of the Shanglin Yuan established the basis for a model of imperial garden design. Today in Beijing's Yihe Yuan (Garden for nurturing harmony) (Fig. 1.1), commonly called the Summer Palace, a lake

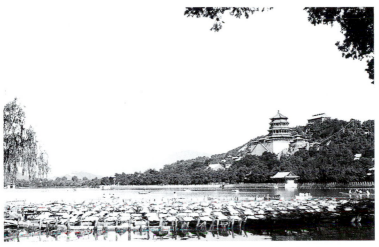

1.1 A scene in Yihe Yuan, Beijing. Courtesy Lou Qingxi.

similar to those of the Qin or Han model bears the same name, Kunming Hu (Plate 1). Of particular significance and symbolic influence to the garden tradition, however, was the building of the Taiye Chi (Taiye pool), to the north of the Jianzhang Palace, by the first emperor of the Han dynasty, Gaozu (r.202 BC–195 BC). As a consolation for the repeated failure of his missions in the Eastern Sea to acquire medicine for achieving longevity and eternal earthly life, he built in this gigantic lake three mountains, namely Penglai, Fangzhang, and Yingzhou, which symbolized three legendary islands in the land of immortality. This symbolic composition of 'one lake, three hills' (or 'three islands in a pond') not only was the earliest conceptual model of garden design in Chinese history, it has been an enduring

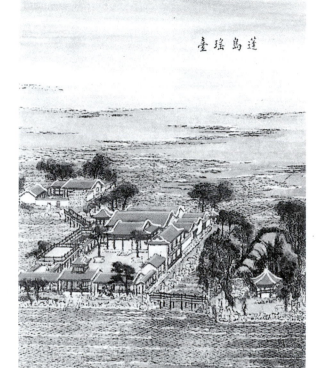

蓬島瑤臺

1.2 'An Immortal Abode on the Fairy Terrace', one of the forty scenes at the imperial park Yuanming Yuan, Beijing, followed the 'three islands in a pond' model of garden design. Courtesy Zhang Shengju.

design theme for imperial and, in some instances, private gardens ever since (Fig. 1.2).

Another popular approach to imperial garden design was the inclusion of replicas of a number of famous scenic spots in a single landscape park (Pan, 1988: 32). Early versions of this model used generic forms of the 'five lakes, four seas, and five mountain peaks' of China set in large

4

natural sites. Later development involved the adoption of specific scenic spots or gardens from around the kingdom. For example, General Liang Jie of the Eastern Han dynasty (AD 25–220) placed in his private garden a gigantic imitation of the famous Mount Xiao of Henan province. The hill remained visible three hundred years later at the same site during the Northern Wei period (386–534). According to historical records of the Tang dynasty (618–907), a large lake named Kunming Chi was dug in the western suburb of the Tang capital, Chang'an. In the lake were piled artificial hills similar to Mount Hua of Anhui province. These famous forms, in varying degrees of likeness to the real scenes, were manipulated as design components according to the genius of the landscape designers. Such an approach was also popular with the landscape painter, as he conceptualized, designed, and executed a landscape masterpiece.

As time went on, the hunting and economic functions of imperial gardens gradually faded away, while the demand for experiencing nature's beauty and tranquillity became more popular. During the Han dynasty, advances in construction technology were evident. By that time, a number of man-made rockeries in the royal establishments had reached 100 *chi* (33 1/3 metres) in height. In addition, large islands were constructed using a great quantity of earth and rocks brought in from quarries away from the site.

Subsequently, in the Northern and Southern dynasties (420–589), the literati school of garden design began to gain influence. As opposed to the 'hunting- and pleasure-ground' and 'land of immortality' models of the Han dynasty, the intelligentsia at that time advocated and popularized the 'mountain and water' style of gardening. In this new orientation, the beauty of nature was revered and the imitation of the natural landscape came into vogue. In those two hundred unstable yet exciting years, reinforced by the

borrowed ideas and techniques used in private gardens, the art of imperial garden design reached a new peak.

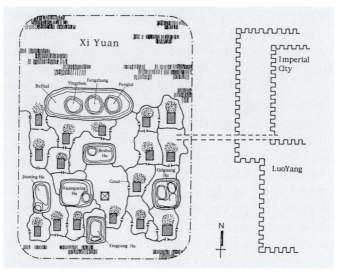

1.3 An imaginary map of Xi Yuan, as it relates to Luoyang, the capital of the Sui dynasty. Developed from a sketch by Taketoshi Kwahara, in *Zhongguo caoyuan shi* (A history of garden building in China), 1991, n.p.

In AD 581, when Emperor Yang of the Sui dynasty (581–618) moved his capital to Luoyang, he ordered the construction of the Xi Yuan (Western garden)(Fig. 1.3), which was comparable in scale to the Shanglin Yuan of Qin and Han times. Although the Xi Yuan continued the 'one lake, three hills' tradition established by the Taiye Chi of the Han dynasty, it used three artificial hills, a lake, a meandering canal, and sixteen palace complexes in a design composition that emphasized the beauty of nature instead of the representation of legendary sites and absorption in recreational pleasures.

The glorious Tang dynasty that followed the Sui enjoyed peace and prosperity unprecedented in Chinese history, and garden construction flourished both in its imperial courts and private quarters. In the capital city of Chang'an alone, there were eight sizable imperial parks. One of these, the Jin Yuan (Forbidden garden) to the north, was larger than the capital city itself! According to documentary records, the Furong Yuan (Hibiscus garden), the most famous of all Tang imperial parks, lay at the south-eastern corner of the capital city and was occasionally open to civilians on holidays. This practice of opening the garden set a precedent in Chinese society for the administration of an imperially owned public park (Pan, 1988: 6).

Although militarily and politically weak, the Song dynasty (960–1279) enjoyed great strides in the advancement of the handicraft industry, science and technology, and literature and the arts, which in turn greatly inspired landscape gardening. Bianjing (currently Kaifeng), the capital of the Northern Song (960–1127), with Luoyang to the west of the capital, became the centres of garden building. Situated around these two cities were Qionglin Yuan (Magnificent forest garden), Jinming Chi (Golden-bright pool), Yingxiang Chi (Welcome auspiciousness pool), and Yujin Yuan (Jade crossing garden). The most grandiose was Wansui Shan (Longevity hill) in the Genyue imperial park at the north-eastern corner of Bianjing. The Emperor Huizong (r.1101–25) started the construction of the hill in 1117, and it took thousands of workers and six years to complete the park. According to Song history, the hill was over 10 *li* in circumference. On its highest peak stood a pavilion that marked a point of separation between the eastern and western slopes. Over the eastern side, thousands of plum trees were planted, while the western slope was covered with lush medicinal herbs.

In the Genyue imperial park, China's five famous mountains (Song Shan, Tai Shan, Tian Shan, Hua Shan, and Heng Shan) and the three gorges of the Yangzi River, along with other rivers and lakes, found their proper places in animated form. The spectacular ways in which rocks were used by Song gardeners in the development of Chinese garden design are particularly interesting. Because of the imposing scale and grotesque forms demanded by the Song artists, the greatest consumption of Taihu and Tianzhu rocks in history was recorded during the construction of the Genyue park.

Historians generally agree that the contribution by the Yuan dynasty (1271–1368) in the development of gardens is limited and easily overshadowed by the works of the Ming (1368–1644) and Qing (1644–1911) periods, the two concluding chapters in the history of imperial China. Efforts in the construction of imperial gardens during the Ming dynasty, however, were limited as well. The only major work undertaken during this period was the expansion of the Taiye Chi in Beijing. Built during the Yuan dynasty, this large pool was incorporated into the Xi Yuan (Western garden), which includes the present-day San Hai (Three seas lakes) in the heart of the city.

It was the Qing emperors, and especially the Emperor Qianlong (r.1736–95), who built splendidly and lavishly during the dynasty's 267-year reign. Their prolific production surpassed that of their ambitious predecessors, the emperors of the Han, Tang, and Song dynasties. In addition to the gardens and parks that they created in the capital city, the Qing emperors built a number of summer palaces and pleasure parks, such as the imperial summer resort at Chengde some 126 miles north-east of the capital, and the 'three hills and five gardens' in a north-western suburb of the capital. Yuanming Yuan (Round bright garden)(Plate 2) is the most famous of these five gardens. Built in 1709 on

8

an 800-acre tract of flat land and developed continually over the next 150 years, the extensive landscape park contained more than 120 famous scenes of unimaginable variety and splendour. The park was destroyed in 1860 by an unruly Anglo–French expeditionary force disputing the torturing of war prisoners. A French missionary once hailed Yuanming Yuan as 'the garden of all gardens', and evidence indicates that it well deserved this proclamation.

In general, most Chinese emperors indulged themselves in garden construction because there was no allowance for large-scale recreational spaces in the design of capital cities and palaces. Bringing nature into the city in the form of gardens was the only luxury the emperors could draw upon in their desire to humanize the places where they worked and lived. The Shanglin Yuan of the Han dynasty, the Xi Yuan of the Sui dynasty, the Genyue imperial park of the Song Dynasty, and the Yuanming Yuan of the early Qing dynasty well represent the evolutionary stages of imperial garden design from a hunting-ground model, through the development of symbolic scenery, to a highly romanticized imitation of natural landscapes.

Imperial gardens can be classified into three general types (Cheng, 1995: 4). The first, the *li gong* ('palace away from the palace'), was built in the suburbs of capital cities or in localities of scenic beauty and environmental comfort. Emperors usually spent prolonged periods, such as the summer months, at the *li gong*. The *jin yuan* (forbidden garden) was usually built next to the imperial palace for easy access on holidays, birthdays, or other festivals. Thirdly, small gardens or courts were built in various parts of the palace proper. One can readily identify the third type of imperial gardens in Beijing today.

Private gardens appeared in China for the first time in the fifth century AD during the Northern Wei dynasty. Their

9

creation grew from a striving for spiritual freedom, as opposed to the materialistic pleasure that motivated the building of imperial gardens and parks. Scholars of the past treasured moral and intellectual development over materialistic comfort and enjoyment. Reacting negatively to the social and political reality of their time, people became hermits in opposition to the status quo. Hermits of early days simply fled to the wilderness of mountainous regions and led primitive lives among birds and animals, often living in caves and hollowed-out tree-trunks. They received spiritual renewal from the nature that surrounded them and were comforted by its beauty and tranquillity. In this environment, many famous hermits throughout history made great contributions to art, literature, and to the development of literati gardens.

There is, however, a marked difference between the hermits of China and their Western counterparts. Hermits in the West were usually associated with religious practices, and they became hermits of their own free will. In China, on the other hand, scholars felt that they were forced to escape society in order to preserve their integrity. Their actions and beliefs were not motivated by religion but were closely related to the teachings of the *dao* (Way) of Daoism and the *ru* (Refinement) of Confucianism.

Daoism, China's native religion, was established during the second century AD. Its practice involved the study of alchemy, indulgence in drinking, performance of local superstitions and magic acts, and the use of elixirs, all for the purpose of achieving longevity and perhaps even immortality. In the Daoist religious construct, a Magic World made of gold, silver, pearls, and jade was created. Although the Daoist Magic World shares certain similarities with the Buddhist Pure Land and the Christian Garden of Eden, Daoist teachings of compassion, humility, and the ending

of selfish endeavours are meant for happiness in an ever-lasting earthly life, not for life after death. Having a religious agenda that coincided with the emperors' dreams, Daoism was wholeheartedly welcomed by China's imperial rulers. This mental construct therefore became one of the sources for the design of imperial gardens and parks.

While imperial gardens and parks borrowed ideas from celestial Daoism as a religion, scholar gardens took inspiration from Daoist passivity as a philosophy. Daoism as a school of thought was led by Laozi, and later by his follower Zhuangzi, who advocated doctrines of 'leave me alone' (*wuwei*), 'desirelessness' (*wuyu*), and 'humbleness' (*juodao*)(Wong, 1997). Their concern for individual salvation and happiness greatly comforted the Chinese intelligentsia, who tended to reject the status quo at a time of societal instability and personal failure (Fig. 1.4). A pragmatic Chinese scholar would enthusiastically embrace the activism of Confucianism at the rise of his career. In times of adversity or set-back, however, he would turn to the passivity of Daoism for consolation and reflection (Cheng, 1995: 8). A private garden—'simple, formless, desireless, without striving'—was an articulation of his desire for a graceful, happy, long life in his retirement.

Most writers have credited Confucianism with the orderly and hierarchical development of Chinese classical architecture and city planning and have considered Daoism as the sole driving force behind the shaping of parks and gardens. In fact, Confucianism shares many similarities with the Daoist concept of nature and deserves greater recognition for its contribution to Chinese landscape design (Cheng, 1992b: 129). Although the overriding emphasis put by Confucius on moral doctrine in world affairs and social relations was the hallmark of his teaching, he also respected modesty and human good-heartedness. His comment that

11

1.4 Wen Zhengming, 'The Elevation for Remote Thoughts', from *Album of the Garden of the Artless Official*, dated 1533. Reproduced from Kate Kerby, *An Old Chinese Garden*, Shanghai, c.1922, n.p.

'the wise takes pleasure in water, the kind finds happiness in a mountain' undoubtedly prompted his followers to seek moral discipline and self-improvement amidst the creations of Mother Nature. 'Mountain and water', referring generally to landscape scenery in Chinese art, are the two constituent parts which became indispensable elements in garden design through the ages.

12

When Confucius spoke of the wise and the kind and their affiliation with mountain and water, he metaphorically implied that the wise scholar took pleasure in applying the great wealth of his talent in the administration of world affairs, much like the never-ending flow of water in a river. The kind gentleman, on the other hand, was happy to remain as firm and stable as a mountain while everything was growing luxuriantly in an undisturbed nature. Gardeners thereafter took hint of this analogy and used 'dig pond and pile up mountains' as an honourable approach to the design of landscape gardens.

Society in fifth- and sixth-century China was unstable, with many intellectuals moving away from the cities in favour of remote but scenic places. One such scholar was Tao Qian (365–427), also known as Tao Yuanming, the greatest poet of the Eastern Jin dynasty (317–420). Tao's refusal to yield to the pressures of political improprieties and his return to a simple rustic life at his hermitage struck a sympathetic cord within the ranks of the disillusioned scholar–officials who had suffered similar personal misfortunes on their way to officialdom. Simple, natural, romantic, and vivid, Tao's pastoral-style poems used powerful imagery to inspire in the reader a nostalgia for a carefree picturesque village life. Consequently, a large number of beautiful villas of high artistic quality came into being. These country estates, large and small, were self-sustaining and made to imitate and complement nature, including the creation of scenes using rocks, trees, and water. These estates were the earliest versions of the private gardens we see today.

Pastoral-style poetry also flourished during the Tang dynasty. Great poets such as Wang Wei (701–61) and Meng Haoran (689–c.740) continued to assert their influence over landscape painting and garden design with their image-provoking words, similar in tone to those of Tao Qian.

Pastoral motifs were widely adopted in garden design, both private and imperial. Later, within the confines of the Song imperial park Genyue, scenes of farmhouses and latticed fields were found in the Xi Zhuang section of the park. Twelve centuries after Tao Qian's time, the pastoral sentiments reappeared in artistic circles. Ji Cheng (1582–?), the great Ming gardener, painter, and author, summarized the themes vividly in his influential treatise *Yuan ye*, which will be discussed in a later chapter.

The development of private gardens reached its maturity during the eighth century. Three hundred years after Tao, the concept of hermitage had experienced a fundamental shift. Due to societal and economic changes, the scholar–hermits were no longer compelled to venture into the wilderness as their only means of 'escaping' society. Instead, they built urban and suburban dwellings for themselves and led a secluded life of art and poetry-writing. In a small and private world of their own, they were able to ward off society and to renew communion with nature, much the same as their predecessors had in the wilderness centuries before. For example, in the Tang city of Luoyang at the end of the seventh century there were more than a thousand private house gardens scattered throughout the city and its suburbs. The number of such establishments was even greater in the capital, Chang'an, where a concentration of government officials, scholars, and rich merchants maintained their residences.

During the fourteenth century, a new theory of landscape painting evolved in China which called for a vivid presentation of emotional expression in the artist's work. This new spirit, coupled with overpopulation across the country, greatly influenced garden design in an urban setting. A method called 'small as large' was adopted, giving the perception of vast space through a modest garden design

on a limited urban site. Furthermore, scholar-hermits began to demand a better life as they became gradually accustomed to an urban life of comfort and plenty. With accumulated wealth, following their retirement (or dismissal in some cases) from government posts, scholars were able to afford more extensive structures and other architectural elements in their private worlds of house and garden. Consequently, in gardens built in the eighteenth century and thereafter, it is not unusual to find architecture occupying one-third of the garden proper (Plate 3). Created as settings for the simple pleasures in life, gardens of the literati in China stood in sharp contrast to the grandiose splendour of their imperial counterparts.

Due to prosperity and an agreeable climate, cities such as Suzhou and Yangzhou in Jiangsu province, as well as Hangzhou in Zhejiang province (Plate 4), became hubs of cultural activity during the seventeenth and eighteenth centuries. A record number of private gardens were built in and around these cities and in other parts of southeastern China. Many of these historic gardens have since faded away. However, a handful of such specimens have survived the ravages of time and still show their charm and elegance to visitors today.

2

The Garden as the Setting for a Good Life

THE HUMORIST and novelist Lin Yutang once observed that we do not know a man well until we find out how he spends his leisure time. It is when, he continued, 'a man ceases to do the things he has to do, and does the things he likes to do, that his character is revealed... and we see the inner man, his real self' (Lin, 1935: 329). In the China of the past, when politics were corrupt, commerce was sordid, society was disorderly, and life was harsh, a Chinese could always seek solace in his own garden, where he enjoyed life freely, happily, and artistically. Making gardens, it may be said, was among the things that the Chinese did best at their leisure.

In China, a house and garden form an organic whole in accordance with the principle of harmony with nature (Fig. 2.1). The garden a man built was always an integral part of his house, and the Chinese concept of a home is explicitly included in the terms *yuanzhai* (garden-house) and *jiayuan* (home-garden). The minimum accommodation for a garden or yard must include, according to Lin, a patch of earth where one can plant vegetables and fruits, a place where children can catch crickets and get comfortably dirty while adults sit under the shade of trees. It also requires a well for the supply of water, a yard for raising chickens and other domestic animals, and a few date trees for food, as well as green shade (Lin, 1935: 329). These are the pragmatic concerns for living. On the other hand, a commonly used term for a garden is *huayuan* (flower garden), a term which demands literally that flowers be planted within the

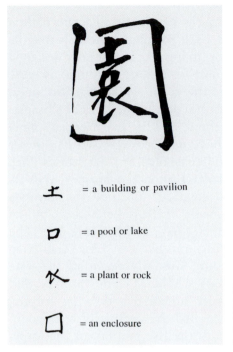

土 = a building or pavilion

ㅁ = a pool or lake

从 = a plant or rock

口 = an enclosure

2.1 The Chinese character *yuan* is dissected into meaningful parts symbolizing the organization and components of a garden.

place. A sensual dimension is thus added for the pleasure of a good life. But a Chinese *huayuan* contains much more than just flowers.

Traditionally, a *huayuan* is composed of trees, rockeries, a pond or lake, zigzag footpaths, winding corridors, bridges, and other garden structures for habitation, quiet viewing, and merrymaking. These elements are arranged in such a way that they are often more artistically designed than nature itself. In this case, a garden is the artistic recreation of nature and considered a landscape painting in three dimensions (Plate 5). The Chinese use the phrase, 'The scenery is like a painting' (*feng jin ru hua*) in praise of a

17

beautiful natural sight, but the phrase has rarely been used in the reverse: 'The painting is like (natural) scenery' (*hua ru feng jin*)(Cheng, 1992a: 132). For the Chinese, it may be said, a garden is an outdoor 'living room', not only designed for the necessities of life but for the art of living, as well.

For the rich, the poor, the royal, and the commoner, gardens have played an integral part in the lives of Chinese. Perhaps mirroring the authors' real-life experiences, many famous domestic novels have used gardens as a barometer for the vicissitudes of the households in their stories (Wu, 1995). A flourishing garden reflected the prosperity of its household, whereas its desolation indicated the family's decline. *Honglou meng* (Dream of the red chamber), by the Qing novelist Cao Xueqin (?–1763), and *Jin ping mei* (The Golden lotus), by the Ming novelist Lan Ling Xiao Xiao Sheng, are good cases in point. Similarly, regarding the state of a nation, the Song-dynasty scholar Li Gefie observed that the rise of a garden culture mirrored a thriving empire, while its deterioration signalled the decline of a kingdom (Wong, 1997). In this regard, the rise and fall of the imperial Yuanming Yuan during the Qing dynasty was among the most vivid testimonies of such a phenomenon in China's long history.

In the novels referred to above, the gardens in these intricate human dramas were each described by the author as a place for the enjoyment of scenery, a setting for romance, an outdoor site for recreation and celebration, and a status symbol of the household. On the other hand, the Yuanming Yuan was used in its heyday by the Qing emperors as a gathering place 'for drinking, admiring the surrounding landscape, composing poetry, and painting in an atmosphere that helped them transcend the real world to a world of relaxation and spiritual pleasure' (Wong, 1997).

Going back in time, literary accounts of the carefree lives

of the hermits of the Wei (220–265) and Jin (265–420) dynasties not only affirm their contribution to landscape painting and poetry writing, but also shed light on the formulation of the literati gardens as an environment (a breeding ground) for developing creativity and accomplishment (Fig. 2.2).

2.2 Qian Gu (1508–74), 'A Gathering at the Orchid Pavilion, 1560'. The Metropolitan Museum of Art; gift of Douglas Dillon, 1980. The painting illustrates a literary event of twelve centuries before, when forty-two scholars gathered at the Orchid Pavilion to drink, compose poetry, and celebrate the annual spring purification festival.

Seeking a good life in the company of their own kind (similar to a poetry club today), scholar-hermits regularly met in gardens and indulged themselves in activities that may have included quiet meditation, abstract philosophizing, composing and reading poetry, painting, playing the zither, concentrating on a game of chess, sampling tea, drinking wine, fishing, boating, picking herbs for medicine, and making pills for immortality (a Daoist practice). This creative solitude and cultivated socializing set precedents for later scholars and artists, as many of these fashionable and respected pastimes continued to be in vogue in garden culture well into Song, Ming, and Qing times.

Night-time garden parties involving members of the literati class were rare, primarily due to difficulties with lighting.

Candles in paper lanterns were used, but they were clumsy to hang and maintain. Activities using gardens as settings at night nevertheless were popular for celebrating particular occasions, such as Yuanxiao, the lantern festival (celebrated on the fifteenth day of the first lunar month), Chinese new year's eve, and Zhongqiujie, the mid-autumn festival (celebrated on the fifteenth day of the eighth lunar month). According to a nineteenth-century edition of the official gazette of Suzhou prefecture, the Wenmuxixiang Xuan (Smelling-the-frangrance-of-osmanthus lounge) in the Liu Yuan (Lingering garden)(Plate 6), the Yuedaofenglai Ting (Moon-appearing-and-breeze-coming pavilion) in the Wangshi Yuan (Garden of the master of the nets), and the Jinsu Ting (Golden millet pavilion) in the Yi Yuan (Happy garden) were popular spots for a quiet family gathering at night on these special dates. Gardens were also used at night as sites for wedding banquets and birthday celebrations. In such cases, garden structures were richly decorated with colourful lanterns and ribbons while food, drink, and music dominated the scene.

The Song-dynasty painter and scholar Guo Xi summarized the requirements for a garden particularly well. In a garden, he stipulated, there must be scenery to be viewed, circulation to be followed, pleasure to be enjoyed, and residential spaces to be utilized (Plate 7). What follows is that to view the scenery, pavilions and terraces had to be built; to allow circulation, trails and paths must be built; to enjoy the garden, places must be created to facilitate poetry reading, fishing, boating, dancing, and feasting; and to accommodate literary friends for overnight stays, rooms and halls must be provided. For the latter, the *ting* or *tang* (hall), *xuan* (lounge), *guan* (guest house), *lou* (two-storey building), and *ge* (two-storey pavilion) were built to contain the library, entertainment, and sleeping quarters. In addition, the *xie*

(waterside pavilion), *fang* (landboat), *ting* (pavilion), and *lang* (covered pathway) were constructed for viewing scenery and merrymaking.

In addition to these requirements, the Ming author and practitioner Wen Zhenheng (1585–1645) set a high goal for the design of gardens. In his *Changwu zhi* (Notes on life's trivialities), Wen demanded that the design of gardens should reach such a state of perfection that the experience of roaming in one would cause the user 'to forget his age, forget to go home, and forget his fatigue'. One such account was recorded by the Ming scholar Qi Biaojia (1602–45), who confessed, 'I would go to the garden early in the morning and come back late at night and leave any domestic business to be attended to under the lamplight' (Lin, 1935: 334). In the Qing imperial court, as well, the Xianfeng Emperor (r.1851–62) lost his sense of time while indulging himself in the sights and scenes of the Yuanming Yuan. A poem describing the Emperor's indulgence reads: 'His Majesty's tour at the Yuanming Yuan tireless as it seems, So his chefs as alert as his guards, get decent food ready on a table anywhere, anytime. Throughout the night till dawn, The kitchen's heat never dies down' (Wong, 1997). Incidentally, during his reign, Xianfeng experienced domestic unrest and foreign humiliation. During these difficult times, the Yuanming Yuan allowed the emperor to forget to go home to his residential palace, to relinquish his fatigue, and even to escape his sorrows, however momentarily.

Many observers reached a state of ecstasy when they came to appreciate the beauty of their gardens. One Qing scholar, for example, found great satisfaction in his petite garden. Despite its size he found in it, 'the view of the mountain, the sound of the water, the colour of the moon, and the fragrance of the flowers. It is like a dreamland that catches your soul and arouses your emotions.' Or a moment

of pleasure was captured in an episode of a spring morning, as Ji Cheng narrated in his *Yuan ye*: 'When sweeping your paths take care of the orchid shoots, and they will send their fragrance into your retreat. Roll up your blinds and greet the swallows who slice through the light breeze like shears.' Ji also helped to stir the pleasant memory of a hot mid-summer day by his description of this scenario: 'From the summer shade of the woods, the song of the oriole starts; in the folds of the hills you suddenly hear a wood-cutter singing, and as a breeze springs up from the cool of the forest, you feel as though you were transported back to the realm of the Emperor Fuxi [the Chinese Adam].' The mountains, the water, the moon, the flowers, the birds, and the breeze amply provided the simple pleasures that were the cherished possessions of rich and poor alike.

Among the materials used for the enjoyment of a garden, wine appears to have been indispensable. While celebrating a scene of unusual beauty in a garden, drinking seemed to provide added incentive for poetry-writing and music-playing. The great Song poet Ouyang Xiu (1007–72) found happiness in his garden, as he often got drunk there while celebrating with his friends. He named the garden Zuiweng Ting (Old drunkard's pavilion) after himself, but he insisted that his real interest was not the wine but the mountains and streams. Intoxicated by the seasonal changes of the garden scenes, he recorded his pleasure in these words:

When the sun rises, the forest mists vanish, and when the clouds return, the crags and grottos fall into shadows; these alternations of light and darkness mark the mountain's dawns and dusks. As the wild flowers blossom, they send forth a subtle fragrance; as tall trees bloom, they yield deep shade; then the winds and frost are lofty and pure, the rivers dry up and their stones are exposed; these are the four seasons in the mountains (Egan, 1984: 216).

In such an earthly paradise Ouyang shared his leisurely life in exile with occasional visits by his closest friends. 'As they may freely fish in the brook, which is deep and filled with meaty fish, or brew wine from the brook, whose water is fragrant and whose wine is clear. To have, in addition, mountain fruits and wild herbs arrayed before one; this is a feast' (Egan, 1984: 216). What a garden—and what a life!

Literary accounts of the joys and pleasures of life in the Chinese garden are abundant, but Chen Fuyao, a Qing scholar, produced by far the most memorable narratives in his *Huajing* (Flower mirror), first published in about 1688. His accounts, which read like an autobiography of a leisurely life, register the fullest extent of his seasonal itinerary in the setting of his naturalistic house garden (Yang, 1988: 71–2).

Spring

Getting up in the morning and after drinking a cup of juice made from plum-flower petals, I went on to supervise servants cleaning garden paths and the house. Afterwards, I read some books on seasonal planting and did maintenance work on the moss on the steps. Approaching noontime, I washed my hands with rose-scented cologne before lighting the delicate *yu rui* incense to refresh the house and also read some passages from the popular literature *Chiwen liuzi*.

At noon, I went out in the garden and picked bamboo shoots and bracken as fuel to heat the spring water for the new tea leaves. In the afternoon, with a jug of wine and two oranges in hand, I rode my old horse to the bird sanctuary to hear orioles singing. Later in the afternoon, I sat under the willow tree and enjoyed the breeze while casually composing a few lines of poetry on my colourful personal stationery. My favourite pastimes in the evening were taking a walk along the garden path, supervising

the gardeners' work on flower-beds, and feeding the storks and fishes.

2.3 A watercolour rendering of the spring scene at the Half Garden, a design for the National Botanical Garden, Washington, DC. Courtesy Liu Binyi.

Summer

As soon as I got up in the early morning, I put on a lotus-leaf quilt as clothing and breathed the moist fresh air of the blossoming trees, at the same time singing and reciting verses of poetry, as a way to teach the parrot to speak. During late morning, I casually read parts of Laozi and Zhuangzi, or practised brush strokes patterned after famous calligraphers of the past. At noon, I took off my head scarf, hung it up over a cliff, and then sat around a bamboo couch with close friends to discuss the scholarly work of *Qi xie* and *Shanhai jing*. When tired, I took a nap and enjoyed a good dream. Thereafter, we had coconut and other fruit as a snack and lotus-flower wine as a beverage. After taking a bath in the evening, I went boating and fishing amongst the vine-lined, winding rivulet.

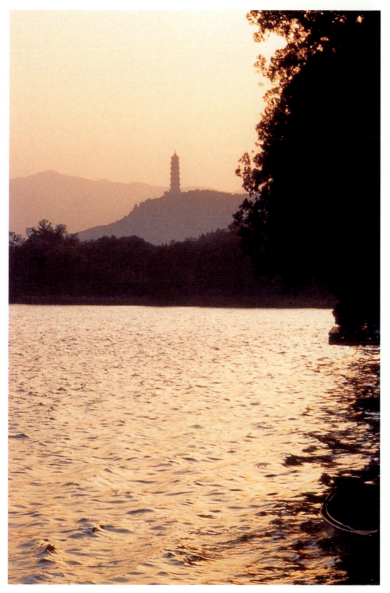

1 An evening view of Yihe Yuan, Beijing, with Yufeng Ta (Jade peak pagoda) and Yuquan Shan (Jade spring hill) in the distance to the west across Kunming Hu.

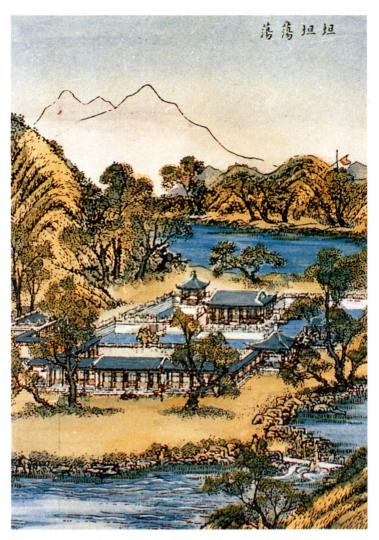

荡荡坦坦

2 Tantan Dangdang (Magnanimous world), one of the forty scenes at the imperial park Yuanming Yuan, Beijing. The entire estate was destroyed in 1860 during China's war with the Western powers. Courtesy Zhang Shengju.

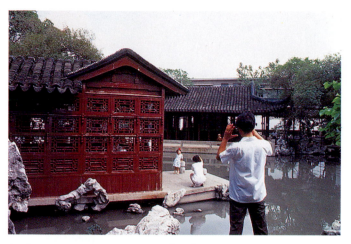

3 A water terrace in Tuisi Yuan (Meditation in Retirement Garden),
Tongli, Jiangsu province, is the setting for an impromptu family
photography session.

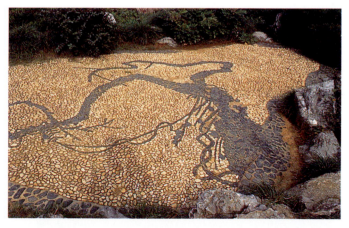

4 The Plum Tree Shadow Terrace at Watching Fishes in the
Harbour of Flowers, one of the ten famous scenes of the West
Lake, Hangzhou. The memory of the beloved tree is kept alive
through the skilled mosaic design.

5 The simplicity and elegance of this residential courtyard in Wangshi Yuan, Suzhou, typifies the taste and aesthetic standard of the Chinese literati of the time.

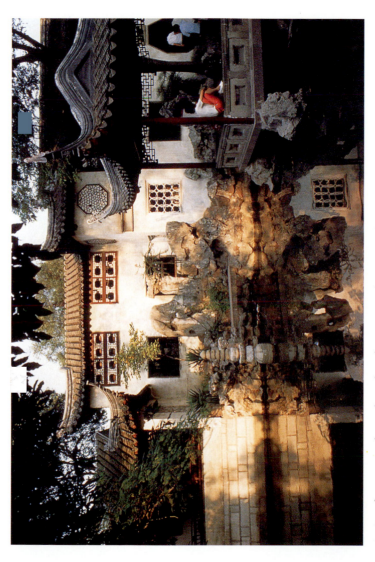

6 Grandeur exists alongside a place for quiet meditation in the confines of Liu Yuan, Suzhou.

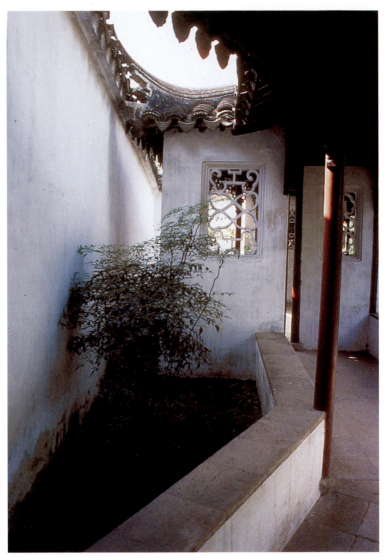

7 In this intimate corner of the east garden of Ou Yuan, Suzhou, architectural elements reinforce an appreciation of the space's flow.

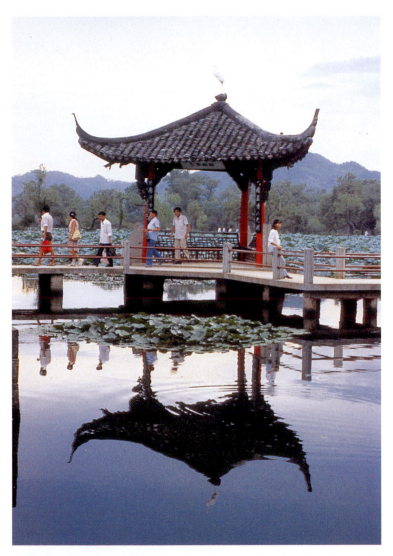

8 A summer scene of Ting Ting Ting (Ting ting pavilion) at Three Pools Mirroring the Moon, West Lake, Hangzhou, shows the use of scenery borrowed from a distance.

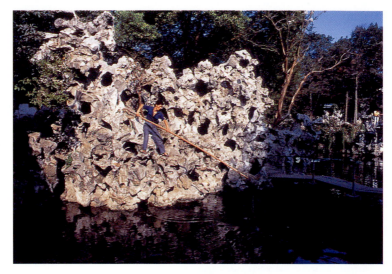

9 A large rockery composition in Shizilin (Forest of lions garden), Suzhou.

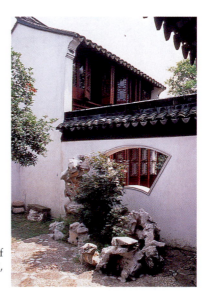

10 A fan-shaped opening in one of the courts at Tuisi Yuan, Tongli, Jiangsu province.

11 The zigzag, covered pathway in the central section of Liu Yuan, Suzhou, offers ever-changing views along the path, much like the unfolding of a landscape painted on a handscroll.

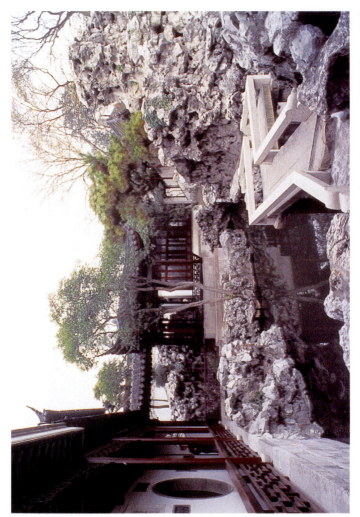

12 The rockeries, bridge, pond, and pavilion of Huanxiu Shanzhuang (Mountain Villa of Encircled Elegance), Suzhou.

13 In the western section of Zhuozheng Yuan, Suzhou, the wavy covered pathway rising, falling, and vaulting the water surface is seen from the lower floor of Daoyin Lou (inverted-image two-storied hall).

14 The interior view of With-whom-to-Sit Lounge, a fan-shaped pavilion, in Zhuozheng Yuan, Suzhou, poetry couplets flanking the window.

15 A winter scene of Xiequ Yuan (Garden of harmonious interest), a constituent garden of Yihe Yuan, Beijing. Courtesy Cao Yang.

16 Plain and humble in appearance, the entrance to Ou Yuan, Suzhou, signals none of the splendours to be found inside its walled enclosure.

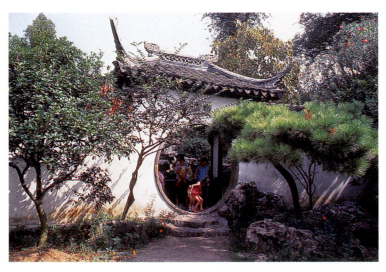

17 The entrance to the east garden of Ou Yuan, Suzhou.

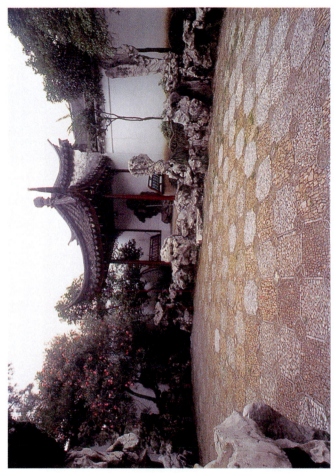

18 Dianchunyi court in Wangshi Yuan, Suzhou, served as the model for designers of the Astor Court at New York's Metropolitan Museum of Art.

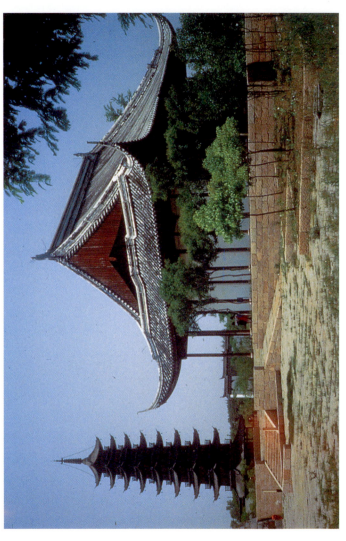

19 The interaction of a Song-dynasty pagoda, a sculptured wall built in 1370, and a temple hall of the Qing period forms the central theme of Fangta Yuan, Songjiang, Jiangsu province.

2.4 Summer at the Half Garden, a design for the National
Botanical Garden, Washington, DC. Courtesy Liu Binyi.

Autumn

Rising up early in the morning, putting down the window curtain,
I carefully picked up with toothpicks the morning dew from flower
petals to be used in red ink mixture for punctuation marks on
literary writings. As noontime was nearing, I played some music
on a zither, trained the storks, and played with my curious collec-
tion of stones and metal pieces. At noon, I washed the ink stand
with a lotus 'head', tidied up the tea set, and dusted wutong and
bamboo trees in the courtyard. I dressed up in hermit attire with
a white casual hat in the afternoon and went outdoors to enjoy
the colourful autumn leaves, jotting down some verses when so
inspired. I then was served crab and perch, and conch soup,
together with newly fermented wine. When drunk, I listened to
the nearby insects singing, the chanting of the boatmen and shep-
herd boys which came from faraway places. At dusk, I lit *bah
yue* incense, cared for the chrysanthemums, watched the big *yen*
birds flying by, and played some music.

2.5 Autumn at the Half Garden, a design for the National Botanical Garden, Washington, DC. Courtesy Liu Binyi.

Winter

Getting up, drinking a cup of fragrant wine before I did my wash-up near a fire. Near midday, cushions for seats were set up, and a fire made up of coal was prepared for the gathering of a scholarly game *hei jing she*. At noon, I opened a bookcase and organized its contents, full of the manuscripts that I had previously composed, watched the slow-moving tree shadows on garden steps, and enjoyed washing my feet in hot water. In the early afternoon, I took the birds in a cage and walked up the mountain cliff full of pine trees. There, I enjoyed tea brewed in cracked ice from the field. Later, I wore a coat made of sheepskin and a hat of sable, and fully appreciated the plum blossoms while riding on donkeyback. Evening hours were spent around a fire with friends discussing the magic of Zen Buddhism while munching on charcoal-baked yams. At night, I indulged myself in the reading of novels on martial art and supernatural beings, regretting the loss of 'sword art' forever.

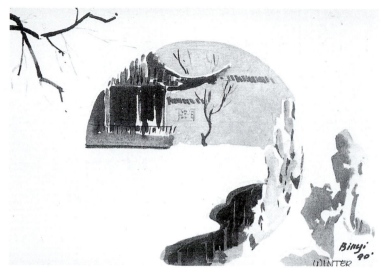

2.6 Winter at the Half Garden, a design for the National Botanical Garden, Washington, DC. Courtesy Liu Binyi.

Although no descriptions of physical features and scenes are offered, the natural beauty and the many accommodations in Chen's garden are implicitly described in these accounts of his typical daily life. Nature was abundant, and the owner content. Chen must have been blessed with the good fortune of having a spacious garden at his disposal all year round. Others may not have enjoyed such a luxury, but they led a good life in nature and with art in their own ways. One such person is Li Liweng (1611–80), a dramatist, designer, epicure, musician, artist, and inventor. Li reported in *Xianqing ouji* (The Art of living) that he had invented a picture window that he named 'landscape window' and had one installed in his small garden Jiezi Yuan (Mustard seed garden)(Fig. 2.7).

27

2.7 Li Liweng's 'landscape window'. Adapted from an illustration by Li Liweng.

Behind his garden studio, Fubai Xuan (Studio of frothy white), a name which itself signified drinking, there stood a miniature landscape Li designed for himself. The assem-

blage had 'a hill about ten feet high and seven feet wide, decorated with miniature scenery of red cliffs and blue water, thick forests and tall bamboo, singing birds and falling cataracts, thatched huts and wooden bridges, complete in all the things that we see in a mountain village'. Li made a window in the studio wall to accommodate the view and 'sat there the whole day looking at it, and could not bear to close the window'. What followed was a sudden inspiration that led to his fuller enjoyment of the garden, art, and life itself. The following passage in Li's own words records his serendipitous discovery of the 'unintentional painting' and epitomizes the art of living in a traditional Chinese garden:

And one day inspired I said to myself, 'This hill can be made into a painting, and this painting can be made into a window. All it will cost me will be just one day's drink money to provide the "mounting" for this painting.' I therefore asked a boy servant to cut out several pieces of paper, and pasted them above and below the window and at the sides, to serve as the mounting for a real picture. Thus the mounting was complete, and only the space usually occupied by the painting itself was left vacant, with the hill behind my house to take its place. Thus when one sits and looks at it, the window is no more a window, but a piece of painting, and the hill is no longer the hill behind my house but a hill in the painting. I could not help laughing out loud, and my wife and children, hearing my laughter, came to see it and joined in laughing at what I had been laughing at. This is the origin of the 'unintentional painting', and the 'landscape window' (Lin, 1935: 272–3).

3

The Garden as Art

THE PREVIOUS CHAPTER showed how the Chinese garden provided charm, natural beauty, and pleasure for its owner and those who used it. It also showed, using Chen Fuyao's account of a hermit-like life as an example, that a residential garden reflected a happy fit between a naturalistic setting and the pragmatic agenda for a leisurely, artistic, and practical life all the year through.

While Chen, a scholar, was happily going about his seasonal activities on his large estate, the artist Li Liweng enjoyed quietly focusing his view on vistas and the details of the various visual elements in his small garden. The lively description given of the episode in which he discovered the 'unintentional painting' attests to his passion for viewing the garden as a painting in three dimensions. Like all garden designers and connoisseurs, Li was deeply concerned and involved with the composition of his garden— the structuring of elements and the organization of scenes as perceived by the eyes of a landscape painter (Fig. 3.1).

In this chapter, the composition or syntax of the Chinese garden will be explored in terms of the principles of garden design and theories of landscape

3.1 The whitewashed wall serves as a canvas and bamboo plants as painting on it. Courtesy Roland Rainer.

painting. To fill out the picture, a simplified design process for a private garden (Zhan Yuan of Nanjing, Jiangsu province) will be used as an illustration of a typical example.

Yuan Ye *and the Theory of Garden Design*

In the world of Chinese gardens, no coherent theory of design was available until Ji Cheng published his *Yuan ye* (The Manual of garden design) in 1634. *Yuan ye*, the only early monograph on Chinese garden design and construction to have survived to this day, is in essence a summation of Ji's lifelong practices of gardening. A painter and garden-builder, Ji was among a small number of first-generation professional gardeners who practised their craft in the south-eastern provinces of China during the late Ming dynasty. His book is a collection of experiences rather than a system of theory and methods, a reaffirmation of long-held conventions instead of a proposal for innovation and revolution. The treatise has been translated into English by Alison Hardie and published as *The Craft of Gardens* (Ji, 1988) by Yale University Press. Its most influential suggestions for garden design are best summarized as follows.

In *Yuan ye*, Ji advocates a natural look in designed scenery so that 'though man-made, it will look like something created naturally' (vol. 1: On Gardens, 43). In Ji's estimation, 'skill in landscape design is shown in the ability to "follow" the lie of the land and "borrow from" the existing scenery; artistic excellence is shown in the "suitability" and "appropriateness" created' in the garden's overall look (vol. 1: A Theory of Construction, 39).

The principle of making use of 'borrowed' scenery in garden design is perhaps the single most important contribution made by Ji. Borrowing from one another, the scenes

in a garden are linked together in a sequence. A garden becomes related to the surrounding environment when it borrows scenery beyond the confines of its walls (Plate 8). Ji thoughtfully encouraged 'borrowing scenery from the distance, near at hand, above you, below you, and at certain times of the year'. In addition, the sounds, colours, and smells from a larger environment could also be borrowed to enhance the enjoyment of a particular garden (vol. 3, chap. 6: On Borrowing Scenery, 121).

Regarding the piling up of 'artificial hills', Ji's treatise offers clear and precise instructions, such as 'If a single rock is set upright in the center as the "chief stone" and two more rocks, known as "split peaks", are inserted on each side, the single one will stand in solitary magnificence and the lesser ones will act as supporters' (vol. 3, chap. 4: On Mountain-building, 106). Significantly, however, the book makes no mention of plants as garden elements.

Although written in general and descriptive terms throughout, *Yuan ye* contains a powerful implication of the design process in the chapter on the layout of the garden. In the layout of the space, the presentation to the visitor of the garden's scenes is given the greatest emphasis. 'The most important element in the layout of gardens is the siting of the principal buildings. The primary consideration is the view, and it is all the better if the buildings can face south' (vol. 1, chap. 2: Layout, 54).

Ji had plenty to say about the use of rocks and water, considered by many Chinese gardeners, both before and after Ji's time, as the two most important elements in a garden (Plate 9). Ji counselled the garden designer to 'build up mountains from the excavated soil and form embankments along the edges of the ponds', as well as offering that 'high mounds can be further heightened and low-lying places should be dug deeper still'. His advice on the manage-

ment of water is most intriguing: 'Water should be allowed to flow freely as if it had no end, and when it blocks your path, build a bridge across it.' This statement can be interpreted to suggest that the shape of a pond should be such that no end (or source) of the water can be seen along the main circulation route. Where the source of the water must reveal itself, one should build a bridge to cover it. An illusion would thus be created to imply that water comes from nowhere, and that it is endless (vol. 1, chap. 2: Layout, 55).

While Ji accepted such elements as winding walkways and zigzag footpaths as unchanging conventions of garden design, he was more liberal in the use of other architectural elements. 'You must search out the unconventional and make sure it is in accord with your own wishes', he advised. 'The trite and conventional should be (totally) eliminated.' He further questioned, 'Why should all the main halls be built the same regardless of their location in the garden? Why set up a pavilion on top of rocks if there is no view from it?' On other aspects of design, Ji favoured great variety in scenery, encouraged sensitive responses to individual site conditions, emphasized the importance of irregularity and asymmetry in design, and promoted elegance and simplicity in construction (vol. 1, chap. 1: Sites, and chap. 3: Buildings, 65).

The highlights of *Yuan ye* as cited above are intended to provide a general impression of how the Chinese garden is composed. Ji's book, however, contains design ideas and general guidelines such as those outlined but fails to offer many clearly defined methods and rules for making a garden. To supplement his writing, suggestions of practical value and artistic interest are readily available from an array of classical literature. One such useful source of a simple genre is called *xiaopinwen*, familiar essays by scholar–gardeners such as Wen Zhenheng, Chen Fuyao, and

Li Liweng. Their casual yet enlightening writings, those quoted in the previous chapter among them, shed useful light on the conception and techniques of design, as well as on the creative ways in which gardens were appreciated.

In addition to the writings of Wen, Chen, and Li, a little memoir by Shen Fu (1763–1808), *Fusheng liuji* (Six chapters of a floating life), contains a discussion of what can be called the 'art of deception' in scenery design for the Chinese garden. Using the formula, 'showing the large in the small and the small in the large, providing for the real in the unreal and for the unreal in the real', Shen deceived and delighted the beholder at the same time by revealing and concealing views alternately, making them sometimes apparent and sometimes hidden. In the chapter titled, 'The Little Pleasures of Life', he wrote:

In the big open spaces, plant bamboos that grow quickly and train plum trees with thick branches to cover them. This is to show the small in the large. When the courtyard is small, the wall should be a combination of convex and concave shapes, decorated with green, covered with ivy, and inlaid with big slabs of stone with inscriptions on them. Thus when you open your window, you seem to face a rocky hillside, alive with rugged beauty. This is to show the large in the small. Contrive so that an apparently blind alley leads suddenly into an open space and the kitchen leads through a back door into an unexpected courtyard. This is to provide for the real in the unreal. Let a door lead into a blind courtyard and conceal the view by placing a few bamboo trees and a few rocks. Thus you suggest something which is not there. Place low balustrades along the top of a wall so as to suggest a roof garden which does not exist. This is to provide for the unreal in the real (Lin, 1935: 331).

While Shen was primarily concerned with viewing scenery and experiencing spaces, an anonymous writer offered an

explicit prescription for the design of an approach to a house garden. As Lin Yutang quoted him in *The Importance of Living*:

Inside the gate there is a footpath and the footpath must be winding. At the turning of the footpath there is an outdoor screen and the screen must be small. Behind the screen there is a terrace and the terrace must be level. On the banks of the terrace there are flowers and the flowers must be fresh. Beyond the flowers is a wall and the wall must be low. By the side of the wall, there is a pine tree and the pine tree must be old. At the foot of the pine tree there are rocks and the rocks must be quaint. Over the rocks there is a pavilion and the pavilion must be simple. Behind the pavilion are bamboos and the bamboos must be thin and sparse. At the end of the bamboos there is a house and the house must be secluded (Lin, 1937: 267).

Concerning the act of designing a garden, the early seventeenth century writer Qi Biaojia would qualify as the spokesman for all garden-makers when he characterized the process as one that was reiterative and by trial and error:

In general, where there is too much space I put in a thing; where it is too crowded I take away a thing; where things cluster together I spread them out; where the arrangement is too diffuse I tighten it a bit; where it is difficult to walk upon I level it; and where it is level I introduce a little unevenness. It is like a good doctor curing a patient, using both nourishing and excitative medicines, or like a good general in the field, using both normal and surprise tactics. Again, it is like a master painter at his work, not allowing a single dead stroke (Lin, 1935: 335).

All three writers seem to have agreed with Ji Cheng, since their respective design approaches all fall within the confines of Ji's preachings. In particular, Shen understood

perfectly the principle of visual perception and had mastered the art of contrast, concealment, and suggestion in the design of his humble garden. Like many scholar–gardeners before him, the unnamed author demonstrated his expertise in luring the visitor through a maze of vistas imbedded with optical temptations and surprises. Qi spoke of the true nature of the creative endeavour which, much like producing a painting, used no formula or logic but subjective and personal judgement based on feelings and vision.

The Theory of Landscape Painting

The seed of Chinese landscape gardening is deeply rooted in the school of landscape painting initiated and formed during the Wei and Jin dynasties. Landscape painting was given the title 'Mother of Garden Art' in recognition of the fact that the gardens and parks of ancient China were almost exclusively designed by painters. Records show that great painters such as Wang Wei of the Tang dynasty, the Song emperor Huizhong, Ni Zan of the Yuan dynasty, Wen Zhengming (1470–1559) of the Ming dynasty, and Shi Tao (Dao Ji)(1641–c.1717) of the Qing dynasty left behind masterpieces capturing the moods and structures of famous gardens of their times (Fig. 3.2). While their paintings served as the inspiration for garden designers, the artists themselves also participated in the design and construction of landscape gardens. Wang Wei's villa at Wangchuan, a hermitage designed for his use, is recorded in a twenty-one scene horizontal scroll, while the ruins of a rockery peak in Yangzhou's Pianshi Shanfang (Pianshi mountain house), designed by Shi Tao, are still visible today.

Inspired by nature's beauty and moved by circumstantial sentimentality, the landscape artist approached garden

3.2 Tang Yin (1470–1520), 'Bamboo in a Spring Thunderstorm'. Folding fan mounted as an album leaf, ink on gold-flecked paper. The Metropolitan Museum of Art, gift of Douglas Dillon, 1988.

design the same way he would execute a piece of landscape painting. These combined talents and the interplay between painting and the garden arts were best described by Ji, when he wrote in *Yuan ye*, 'Treat the whitewashed wall as if it were paper, and the rocks as painting upon it' (Ji, 1988: 109).

Rockery formation, in particular, was influenced the most by and benefited the most from painting, as Kan Duo, a modern-day scholar, commented in his foreword to the 1932 edition of *Yuan ye*: 'Mountain-building in a garden derived its art from painting in that the painter uses brushes and ink, while the rockery artist employs rocks and earth as design media. Whereas the media they use are different, the principle of design is the same' (Ji, 1932: 18). What the garden designers really learned from painters was, as Ji advised, to 'study the natural cracks in the stone, and imitate the brushwork of the old masters'. In fact, at the height of garden art during the late Ming and early Qing dynasties, the most popular mountain-building approach

3.3 The texture strokes of rocks and mountains by a variety of painters were used as models for building artificial hills in gardens. Adapted from Huang Changmei, *Zhongguo Tingyuan yu Wenren Sixiang.*

used modelling after the texture strokes (*cun fa*) and pictorial compositions of the master painters of the Yuan dynasty, which immediately preceded those times (Fig. 3.3).

In the works of the Four Great Literati Painters of the Yuan dynasty, the mountains of Huang Gongwang (1269–1354), composed of smaller pieces of crystals, appear grandiose and heavy; the innumerable mountains and valleys by Wang Meng (c.1308–85) are misty and finely crafted. Ni Zan (1301–74) was famous for his depiction of withered trees in combination with bamboo and rocks. His composition was simple and sparse, yet it projected a strong sentiment of loneliness and sadness. The broad, misty, and remote mountain views by Wu Zhen (1285–1354) added to the rich palette of ideas and patterns from which gardenmakers freely drew in their work.

In a more direct way, the principles of painting—specifically, the syntax of composition used in painting—have been successfully applied to garden design. Of particular interest to a visitor at a Chinese garden is yet another parallel between the creation of the garden and painting. In Chinese painting conventional formats include the vertical and horizontal, the handscroll, and the juxtaposition of individual frames. In addition, fan-shape, circular, octagonal, and other geometrical formats are also popular. Deliberately and thoughtfully, these geometrical forms are employed in the openings in architectural elements of the garden (Plate 10). A garden can thus be experienced as a three-dimensional painting in which pictures are framed

3.4 Some of the tracery windows used in Chinese gardens. Adapted from Liu Xujie, *Classical Gardens of Suzhou.*

by a variety of devices, including windows (Fig. 3.4) and openings in the garden walls (Fig. 3.5). As the visitor moves along a garden path, scenes will unfold in space and time much as if a handscroll were being unrolled (Plate 11).

Another powerful principle often applied in Chinese painting is the use of scattered vanishing-points in perspec-

3.5 'Moon gates' of various shapes used in Chinese gardens. Adapted from Liu Dunzhen, *Classical Gardens of Suzhou*.

3.6 An imaginary panorama of Daguan Yuan (Grand view garden), from *Dream of the Red Chamber*, provides a good example of the versatility of using the scattered vanishing-point technique in perspective drawing.

tive drawing. As opposed to the Renaissance perspective technique in which one, two, or three vanishing-points are used in creating a picture, Chinese artists had the liberty of utilizing as many vanishing-points as they deemed necessary to depict a particular scene (Fig. 3.6). Using this versatile technique, also referred to as multiple vanishing-point perspective, Chinese artists were able to enjoy a complete freedom in content selection, sequencing, layout, and composition, based on their impressions and feelings about the task at hand. This freedom of movement, as well as the placement and sequencing of the 'pictures', greatly benefited the design of gardens and parks.

Selected Examples from Theories of Landscape Painting

Whereas explicit statements of the methods of garden design are a rarity in Chinese literature, theories of landscape painting abound and have guided garden design through the crucial stages of its long development. Many of the theoretical statements by painters have sounded equally useful to landscape gardeners, as they covered nearly all aspects of the composition of a garden. Some popular, instructional quotations and comments are illustrated below as examples.

Concerning composition

[In a landscape painting] there must be a 'host' and 'guest' in mountains, to and fro in water, tortuousness in hills, up and down in a mountain range, ...branching off in roads, revealing and concealing in streams, and high and low in curved river banks (Jing Hao, *Shanshui jieyao*, An Outline of landscape painting).

41

Concerning process

[Getting ready to execute a painting in front of a blank sheet of rice paper, one should] look up and down, left and right, within and beyond [the picture frame], toward you and away from you, when 'a complete bamboo is in your chest' [meaning having a well thought-out scheme], then start painting with ink and brush (Wang Yuanqi, *Hualun shize*, Ten rules of painting).

First establish the 'host' and 'guest' positions of the mountains. Next, decide on the 'near' and 'far' locations of the images. Then, place scenic objects between mountains and rivers so that they are up and down and in various heights (Wang Wei, *Shenshui jue*, The Secret formula of landscape painting).

Concerning mountains

Because of the prominent role rockery played in a garden scheme (Plate 12), a great deal of attention was paid to the study of its methods and techniques. Wang Yuanqi (1642–1715) included a lively discussion of the techniques of painting mountains in his *Yuchuang manbi* (A Rainy-day window-side chat), in which he compared the dynamic movement of a mountain range with that of a dragon. In a dragon head, he observed, there are slanting lines and levelled ones, whole and fragmented, continuous and broken, visible and hidden ones. Using that observation as the basis for an analogy, the 'design' of mountains in a painting could involve opening and closing, high and low, and also grouping, separation, gentle rippling, dramatic cliffing, peaking, and levelling.

In addition to the practice of making reference to the Four Great Literati Painters' statements about styling concerns, as was outlined above, gardeners also learned from painters the perceptual aspects of mountains.

Observations such as these were instructional: 'Spring reveals the mountain's appearance; summer, its "qi" or mist; autumn, its mood; and winter, its skeleton.' Also, 'The mountain appears low at night, close by on a fine day, and tall at dawn.'

Scholar–gardeners made metaphorical parallels between the ever-changing natural phenomena and the changing of human emotions. Believing that all things were endowed with sentiments and feelings, the Song painter Guo Xi made this observation about mountains: 'The spring mountain with misty clouds makes people active and happy; the summer mountain, covered with shady forest, makes people peaceful and poised; the autumn mountain, with bare tree trunks, makes people serious and solemn; and the winter mountain with obscure views makes people passive and lonely.' In the eyes of a painter, these expressions were translated as: 'A spring mountain appears to be smiling; a summer mountain seems open-minded; an autumn mountain, well-groomed; and a winter mountain, sleepy.' These mountain images have been skilfully incorporated into garden designs to create various moods and emotions.

Concerning plants

Distant mountains show no base, distant trees show no roots, and distant boats show no hulls [only sails are visible].

The personification of plants also provided a source of design for sceneries of particular sentiment and significance. In most cases, plants were employed to symbolize the high character of a scholar–official or the unusual beauty of a woman. Stressing the importance of flowers as ingredients of a garden, Chen Fuyao, in *Huajing*, declared, 'If there is no good flower in a garden, it will be like a beautiful mansion without a gorgeous woman in it.' Likewise,

in *Honglou meng* every female character in the story has been assigned a flower as a symbol of her particular personality and beauty. To further highlight the ladies' individuality in the overall garden setting, corresponding floral species were said to have been planted in the courtyards of their respective living quarters.

In terms of symbolic meanings, pine, bamboo, and wintersweet are popularly personified as the Three Good Friends of Winter, due to their perseverance and unconquerable spirit in the face of freezing cold and hardship. Similarly, plum, orchid, bamboo, and chrysanthemum are considered the Four Virtuous Gentlemen. The lotus flower is respected for its purity and integrity, because of its ability to survive the 'muddy world' without being contaminated. On the other hand, the peony, known as the King of Flowers, symbolizes wealth and prosperity with its brilliant colours and majestic appearance. These plants, assigned auspicious meanings, romantic sentiment, and didactic influence, are not merely individual plant materials useful for the 'landscape' of the eye. They are the essential ingredients for the 'inscape' of the mind (Murck and Fong, 1991: 361).

Concerning water

Mountains are valued for their range, water is valued
 for its source.
Streams follow mountains, and mountains are brought
 to life by streams.
For the mountain, streams are its veins, grass, its hair,
 and mists and clouds, its expressions
 (Guo Xi, Song dynasty).

Mist is best for mountain-and-river scenes, clearness is important for the borderline between forest and mountain range, terrain has

its highs and lows, objects large and small, scenes near and far, deep and shallow. Mountains by nature are static but can be mobilized by the meandering water around them; rocks are basically stiff but will come alive when trees are added (Da Chongguang, *Hua quan*, Keys to successful painting).

For the scholar-gardener, his most cherished goal was to be able to use his creation as a vehicle to embody and convey to beholders a specific set of *shi qing hua yi* (literally, 'poetic sentiments and artistic conceptions'). Poetry and landscape painting were found to be the most effective tools for achieving these goals. The *qing* (sentiment or feeling), best expressed in a poem, and the *yi* (conception or idea), to be found in a landscape painting, helped establish his ultimate design objectives for a particular garden scheme. As a result, an enormous wealth of *hua lun* (theories of painting), along with poems and prose from the past, became bounteous resources at his disposal.

A Design Process

The example of a design illustrated in Figure 3.7 was developed from the southern courtyard of the Zhan Yuan, an early Ming dynasty garden located in Nanjing. In this illustration, the design procedure does not necessarily reflect the actual process by which the Zhan Yuan was designed and built—no such document ever existed in Chinese garden history. It was reconstructed as an academic exercise to demonstrate what the design of a traditional Chinese garden would entail.

A: Once a site was selected, the first decision would invariably establish the siting of the main hall. Ideally, the main hall should be located in the northern section of the

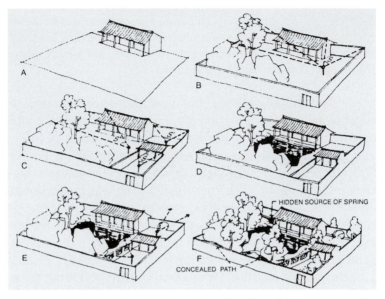

3.7 A garden design process reconstructed. Adapted from *Jianzhu Shi*, courtesy of Wang Boyang.

garden, facing south when possible and overlooking the best scenes that the garden would provide.

B: The garden proper was enclosed on all sides, usually by high walls, which were an integral part of the garden. Ancient trees were desirable and 'artificial hills' necessary. The heights of the main hall, trees, and rocks were decided (except for existing trees) to allow the proper 'borrowing', in Ji Cheng's terms, of scenes from above the garden itself.

C: Skilful subdivision of spaces would make a small garden appear large and, at the same time, provide varieties of scenery in the garden. Subdivision was the key to

the creation of a sense of boundlessness in space within a limited site.

D: A pond was created as a final touch for the composition. An indispensable element, water not only gave contrast to rockery and provided a mirrored image of scenic objects, it also gave life to and mobilized the static artificial hills in a garden scene.

E: A variety of latticed windows were used to lure the visitor into the garden's space. A moon gate and other geometric openings were employed to frame garden scenes and to create depth of space. As a rule, no dead end was allowed in any garden space. The climax of a garden was reached only by following a carefully designed sequence of 'hiding', 'leaking', and 'revealing' scenes of enchantment, as the visitor was never allowed to see the panoramic whole of the Chinese garden at the outset.

F: To complete the design, the final step was to hide the source of the pond and to conccal the footpath amidst mountains and valleys.

4

The Garden as an Ideal

THE VIEWING of the Chinese garden as a picture-in-three-
dimensions was the basic premise for discussions of the
visual or compositional approach to garden design. Exploration
of the affective or semantic dimension, however, relies on
other sources in addition to the physical setting of the
garden itself. Providing a sense of the feelings aroused by
the experience of a garden, an analysis of landscape paint-
ings that incorporate poetry yields useful insights into the
semantic dimension of Chinese garden design.

Wu Zhen was among the best of the painter–poets of the
Yuan dynasty. His handscroll *Yufu* (Fisherman)(Fig. 4.1)
bears an inscription by the artist in the picture which reads:

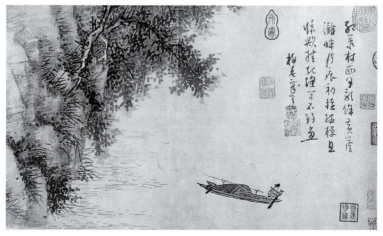

4.1 Wu Zhen, 'Fisherman'. Handscroll, ink on paper. The Metropolitan
Museum of Art, bequest of John M. Crawford, Jr., 1988. (1989.363.33.)

West of the village, evening rays linger on red leaves
as the moon rises over yellow reeds on the sandbank.
The fisherman moves his paddle,
Thinking of home—
his pole, lying in its rack, will catch no more fish today
 (Murck and Fong, 1991: 443).

As can be noted, the first line of the poem refers to a village, yet none is depicted in the painting. It is apparent that the poem in this case adds images to the total visual field of the scenery. Furthermore, continuing along the first line, the poem tells us that the leaves are west of the village. Following this clue, the viewer could conjecture that the village would lie somewhere to the right of the painting, in fact, in the direction the fisherman is facing. The last three lines tell the intention of the fisherman, that he is thinking of going home, presumably to the village, as he 'will catch no more fish today'. Back again to the first line of the poem, the leaves are described as red, while the following line mentions the traces of the rising moon over the yellow reeds on the bank. In the absence of a moon in the painting, its presence is suggested by the shadows the reeds cast, subtly, in the moonlight.

Because the painting has been composed entirely in shades of black ink, the 'colours' of the leaves and reeds are recognized only through the words of the poem. The poem first augments the *jing* (scenery) of the painting and then describes the *qing* (feeling) of the lone fisherman. It informs the viewer of a setting in time (an evening in autumn), a wider pictorial field (including a village in the distance), and above all, the psychological state of the protagonist in the painting (the fisherman's longing for home following a day's work). All this information would have been unavailable without the inscribed poem on the painting.

Literary inscriptions have been similarly used in the composition of Chinese gardens. As with Wu's *Yufu*, in which images and poetry complement each other to give the viewer the fullest possible appreciation of a landscape, poetry and verses were traditionally incorporated into a garden scheme to bring a semantic dimension, or meaning, to the garden's scenes. In Suzhou's Zhuozheng Yuan (Humble administrator's garden)(Plate 13), for example, the name of the Yuanxiang Tang (Hall of distant fragrance) was taken from a verse, 'fragrance in the distance makes it even more pure and distinct', from the popular treatise *Ailian shuo* (The Love of lotus) by the Song-dynasty philosopher Zhou Dunyi. A follow-up verse, 'growing out of muddy waters yet remaining uncontaminated', was read with equal attention to its meaning. The association of Zhou's first verse with the building tells the visitor that there are fragrant flowers at a distance from the hall. Although no plant is mentioned by name, the second verse hints that it is lotus blossoms that emit the fragrance. Submerged in this mental context, the knowledgeable beholder would be all the more appreciative of the Yuanxiang Tang's prominence as one of the major scenic spots in the Zhuozheng Yuan. Its prominence, due to its relative size and central location, was further enhanced by the presence of lotus blossoms and recognition of their prominence as a central Buddhist symbol.

In China, each garden bears a name, much like a painting with its title. The name, often elegantly calligraphed and prominently inscribed on the garden gate, reflects the character of the garden, and to a greater degree, the disposition of its owner–designer. The Ge Yuan in Yangzhou (Fig. 4.2), for instance, has a simple name—meaning 'one' or 'single'— and an equally simple entrance gate. At the gate, several shapely bamboo trees adorn the moon-shaped entrance on a white garden wall. Above the entrance gate are two

4.2 The entrance to Ge Yuan, Yangzhou, Jiangsu province. Courtesy Xu Dejia.

Chinese characters, 'Ge Yuan', inscribed horizontally in a rectangular relief. At first glance, the pictorial composition appears plain and unpretentious, and few would be able to comprehend the subtlety behind this ordinary façade. The key to the comprehension of the scheme, however, rests with the character *ge*, which holds a similar role as the inscribed poem on Wu's *Fisherman*. The shape of *ge* in calligraphy resembles one-half of the Chinese character *zhu* (bamboo), the symbol of unyielding integrity in the Chinese mind. Indirectly and by implication, Huang Yingtai, the Ge Yuan's first owner, no doubt considered himself the single and only remaining bamboo branch left in this troubled world. He wanted others to appreciate his good character through the naming of his garden.

The traditional practice of assigning names to gardens, and to the buildings and sceneries within them, started during the Qin and Han dynasties and has since become

51

an integral part of garden design in China. Names, couplets, poems, and chronicles about the gardens have been written or carved on specially designed boards and tablets in either horizontal or vertical formats (Plate 14). Literary expressions are also found on upright stone tablets, steles, rocks, and on cliff-sides in gardens and scenic spots. Aside from their ornamental value, these works serve as a kind of 'guide book' of the garden tour. More importantly, they originally provided the owner–designer, and his literary colleagues, ample opportunity to show off their scholarship and skills in calligraphy and poetry-writing.

Historically, emperors and scholars each indulged themselves in garden construction, but with different motivations. Building elaborate and extensive gardens for their exclusive enjoyment, imperial rulers took the luxury for granted, because by tradition there was no allowance for recreational open spaces in their palaces. To justify their actions, gifted emperors utilized 'garden literature' as a medium to glorify their accomplishments, to wish for world peace and a good harvest, to memorialize ancestors, or to show off their righteousness and scholarship (Plate 15). Portraying themselves as kind, scholarly, and capable rulers, emperors routinely promoted their self-image through the use of poems and verses in their gardens and parks. The overriding tone of their expressions was positive, direct, didactic, and auspicious, while the messages delivered through the designed landscapes were the inward concerns for the well-being of the empire and its citizenry.

Private gardens, on the other hand, especially those built in the literati tradition, held deeply rooted negative messages. As the chapter on the historical development of the Chinese garden indicated, private gardens were most often built as expressions of denial, self-protection, and seclusion in response to the buffetings of an unstable and chaotic society.

Most owner–designers of these gardens were intellectuals who had experienced set-backs in their governmental careers. Not surprisingly, there is an overriding anti-establishment sentiment and a defensive mentality surrounding the art and craft of garden-building. More often than not, the prevalent message was, 'The court has wronged me'.

Gardens, therefore, were not only their retreats in exile but also an appropriate vehicle for members of the intelligentsia to tell stories that were untold, air grievances that were undisclosed, describe dreams that were unfulfilled, and propose visions that had not materialized. In other words, intellectuals used their private gardens as an art form to express their opinions about the affairs of the world, much as poetry was used to air their inner feelings. For fear of retaliation and unwanted punishment from the imperial court, the language they used was negative yet subtle, sarcastic yet indirect, and melancholy yet with pride. Although tinted with personal emotions, a private garden embodied universal ideals that strove for oneness with nature and transcended the confines of a small, enclosed microcosm. In this way, it was the antithesis of its imperial counterpart.

As an expression of an ideal, a Chinese garden can be read as a metaphysical embodiment of an ideal romance (stories untold), an ideal character (undisclosed grievances), an ideal ambition (dreams unfulfilled), or an ideal world (visions not utilized), in which the *qing* (feelings captured while 'flowing' from literature) and the *jing* (form embodied in scenery 'projecting' out of visual images) have been merged into one (Sun, 1982: 46).

The Ou Yuan (Twin garden)(Plate 16) of Suzhou is a good example of a garden designed as a setting for romance. The result of a renovation that added a wholly new garden to an existing site, the modern setting fittingly began with

the name *ou* ('a couple' or 'mates'). Yet another character *ou*, meaning 'a pair' or 'two', was also used at that time for the garden. Coincidentally, residential quarters divided the site into the two separate gardens, one in the east and the other in the west. With the help of a painter, the retired official Shen Bincheng and his wife, late in the Qing dynasty, built this house garden for their retirement on the outskirts of Suzhou. Simple pleasures and a rustic life were the theme of the design, while the equally simple and cozy scenes of 'mountains and water' were the setting for the romance-for-life. A century later, in today's Ou Yuan, the Shen couple's good life in the house garden can be recaptured in sight and sound by following their footprints through the intricate weavings of pictures and poetry in the garden's scenes.

Upon entering the garden in the east (Plate 17), one sees the horizontally written calligraphy *zhen bo shuang yin* (retired couple on flowing water), which gives the first hint of the nature of this house garden. The name of the main hall, Chengqu Caotang (City-corner cottage), in the north, accurately delineates the overall context for the space. This name was derived from a verse by the Tang poet Li He (719–817) that reads, 'female cow crosses the heavenly river; misty willows are all over the city corner'. The cottage itself, standing just outside the city proper, expressed the owner–designer's preference for a simple and rustic life, but the two characters 'female' and 'cow' were not included as a part of the name. Referring to Chinese mythology, the two characters are in effect shorthand forms for 'the *female* weaver' and 'the *cow*boy', the two leading roles in the love story seen in the Chinese Milky Way.

As the Shens spent a great deal of time studying the classics and weaving curtains (a family business), Cangshu Lou (the library) and Zhilian Laowu (Old curtain weaving lodge),

both located in the west garden, provided the perfect setting for their lives together in leisure. Romancing each other, again, in the east garden, they enjoyed the sights and sounds in the Sanshuijian (Pavilion amid the hillock and pond), the Wuai Ting (Sweetheart pavilion), and the Tinglu Lou (Hall for listening to the sculls).

Marital bliss aside, the Chinese also cherished lasting friendship as a form of romance. Tongyin Guan (Music-from-the-tong-tree guest-house) in Nanjing's Xu Yuan (Warm garden) has a moving story behind its name. The guest-house was surrounded on all sides by *tong* trees, which gave a clue to the significance of the story. According to the narratives in *Lushi chunqiu* (Lu's annals of spring and autumn), Yu Boya was a high-ranking official during the Spring and Autumn period (770–476 BC). An accomplished amateur zither player, he regularly practised his art in a secluded wilderness. His only admirer happened to be a hermit named Zhong Ziqi, who lived in the mountains as a woodsman. Over the years, a deep friendship developed between the musician and his faithful audience, as Ziqi was able to appreciate fully the hidden messages in Boya's music. The 'romance', however, was abruptly ended as Ziqi suddenly died of poverty. Out of profound sadness, Boya broke his instrument and never played his music again. The wood of the *tong* tree was known as one of the best materials for making Chinese guitars. In the absence of a faithful admirer, and in honour of Ziqi, the Xu Yuan's owner planted *tong* trees around the guest-house and named it Tongyin Quan. Did he also miss his sole admirer?

In government service, as in everyday life, a member of the Chinese intelligentsia would vehemently protect his personal integrity as his most valued virtue. When it was violated, poetry-writing and garden-building appeared to be the only vehicles for him to clear his name and air his

grievances. Such instances are numerous and the building of the Ge Yuan, as discussed earlier, is but one example. By giving his garden the name *ge*, Huang Yingtai was known in history as a man who cherished honesty and justice. A similar story of the naming game is equally revealing. It involves several of Suzhou's famous gardens and a wise fisherman of the Warring States period (475–221 BC). After the great poet and statesman Qu Yuan (*c.*340–*c.*278 BC) was sent into exile by the Chu king, he met a fisherman one day at the river-bank. Their conversation led them to talk about the causes of Qu's apparent unhappiness.

Describing his personal circumstances, Qu recited the famous verses from the *Chuci* (Songs of Chu): 'While the whole world is corrupt, I am the only one who is clean; while the whole world is drunk, I am the only one who is sober.' Sympathetic and laughing, the fisherman responded, singing, 'If the *cang lang* [blue waves] were clean, I would wash my tassel in them and join in to serve the King; if the *cang lang* were muddy, I would wash my feet in them and enjoy a carefree hermit life instead.'

The term *cang lang*, taken from the fisherman's song, was later adopted for Canglangting Yuan (Surging-wave pavilion garden), the oldest surviving garden in Suzhou. But the story of Qu Yuan inspired the design of other gardens in Suzhou, as well. There is a Xiaocanglang Ting (Little *cang lang* pavilion) in Zhuozheng Yuan and in Yi Yuan, and a Zhuoying Shuige (Washing-tassel water pavilion) in Wangshi Yuan. In memory of the fisherman, another garden in Suzhou was named Yuying Yuan (Fisherman hermit garden). Its name was later changed to Wangshi Yuan. *Wangshi* (master of the nets) clearly refers to the fisherman.

Emperors also were not bashful in telling the world about their good characters and great deeds through gardens and parks. As a part of the 'forty scenes' designated in the impe-

rial Yuanming Yuan in 1744 by the Emperor Qianlong, *Zhenda guangming* (Just and honourable) referred to the Emperor's honourable personality. *Qinzhen qinxian* (Diligent and affectionate) made reference to his virtues of diligence and kindness. *Changchun xiangguan* (Ever-spring fairy house) was meant as a filial expression for the Queen Mother, and *Hongci yonghu* (Great kindness and eternal blessing) was devoted to the memories of the Emperor's father and grand-father as an expression of ancestor worship. For each of the forty scenes, Qianlong composed a poem. In addition, he commissioned court artists to paint all the views on silk as permanent records to celebrate his impeccable character, great administration, and high scholarly attainment (Wong, 1997).

While scholars and emperors took pride in their good virtues and portrayed them in their gardens as models of an ideal character, such acts implicitly revealed their desire to pursue unfulfilled dreams as well. The never-attained dream of all Chinese emperors was to seek and sustain happiness in an eternal earthly life (emperors were addressed as *wansui*, literally 'ten-thousand-years of age'). Not surpris-ingly, many designed scenes and architectural forms in imperial gardens that bear auspicious names such as those of the Wanshou Shan (Longevity hill) in Beijing's Yihe Yuan and the Xumifushou Miao (Buddhist temple of blessing and longevity) at Chengde. Both the pine and the crane signify longevity, and so we have the Songhe Zhai (Pine-and-crane studio) within the Bishu Shanzhuang (Summer-retreat moun-tain villa) at Chengde. All these names sing to the impe-rial rulers' wishes and desires.

In contrast to the grandiose ambitions of the emperors, Chinese scholar–painters appeared to shun wealth and power, instead preaching a doctrine of simplicity and naturalness as the most meaningful lifestyle. Chuyue Xuan (Hoe-moon

lounge) in the Yi Yuan, Suzhou, suggested ridding the rice field of weeds, and the Huafang Zhai (Painted pleasure boat-house) in many private gardens symbolized a safeguard against undesirable, usually political, storms, much like Noah's ark in the Bible story of the West. A simple life, good social relations, and clean politics were an integral part of the scholar's (unfulfilled) lifelong ambitions and wishes.

Of all the poets mentioned so far in this discussion, Tao Qian of the Jin dynasty was perhaps the most influential in bringing visionary ideals to garden design. Living and working during one of the most troubled times in Chinese history, he became a symbol of hope and solace when he published the heart-throbbing work titled *Taohua Yuan Ji* (The Peach-blossom spring)(Fig. 4.3). The work's fable-like prose described how a fisherman accidentally discovered a happy land as he was rowing aimlessly one day along a stream:

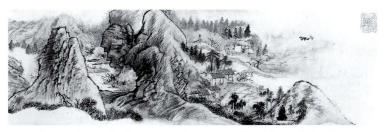

4.3 Shi Tao (Dao Ji), 'Illustration for an Episode of the Tale by Tao Qian, "The Peach Blossom Spring"'. Section of a handscroll, ink and colours on paper. Freer Gallery of Art, Washington, DC.

He suddenly came to a grove of peach trees in bloom. For several hundreds of paces on both banks of the stream there was no other kind of tree. The fragrant flowers were fresh and beautiful; fallen petals lay in rich profusion.... Where the [blossoming peach] grove

ended at the stream's source there stood a hill, in which there was a small opening.... At first extremely narrow,...it opened out into a broad, level plain where houses and huts stood neatly, with rich fields and lovely ponds, mulberries, bamboos and the like. The field dikes crisscrossed; chickens and dogs could be heard from farm to farm.... White-haired elders and children with hair in flowing tufts were all happily enjoying themselves. When [the people] saw the fisherman, they were greatly surprised.... Then they invited him to their home, setting out wine and killing a chicken to prepare a meal.... They said their ancestors fled from the troubles of Qin times... [and] asked what dynasty it was now; they knew nothing of the existence of the Han, let alone the Wei or the Jin (Kwong, 1994: 51).

Unlike a pure fantasy, the narrative of the Peach Blossom Spring dwells on the description of a simple village community that appears to be down-to-earth and familiar to 'outsiders'. Poised between the poles of fact and fiction, Tao was able to stimulate the imaginative minds of poets, painters, and garden-designers as they set out to create their ideal worlds and imagined utopias according to their own agendas and emotions.

5

Present and Future

IN THE WINTER of 1979, a team of twenty-one craftsmen and a chef from Suzhou travelled to New York City to build a Chinese garden at the Metropolitan Museum of Art. On the second floor of the museum, the skilled Chinese artisans, working with prefabricated parts and other vernacular materials shipped from China, installed a Ming-style courtyard. This marked the first major cultural exchange between the People's Republic of China and the United States since the 1972 normalization of relations between the two countries. The garden was named Ming Xuan (Ming lounge) but is better known as Astor Court (Fig. 5.1), in honour of its benefactor. While the museum's inclusion of

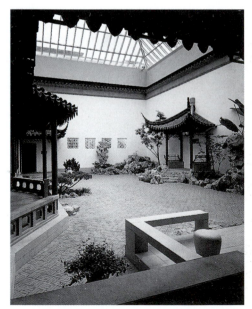

5.1 The Cold Springs Pavilion, rockeries and plants, and a covered pathway are viewed from the Late-spring Chamber in the Astor Court. The Metropolitan Museum of Art, gift of the Vincent Astor Foundation, 1980.

a Chinese garden in its collection was itself a history-making event, the content of the new addition brought along with it a touch of its own history. The Astor Court is a replica of the Dianchunyi (Late-spring chamber), a small section of Suzhou's highly regarded Wangshi Yuan, which was built during the mid-eighteenth century (Plate 18).

Since 1979, more than thirty-five Chinese gardens of various sizes and types have been built in fourteen countries in North America, Europe, Asia, Australia, and Africa. Between 1983 and 1993, five gardens were constructed in the German cities of Munich, Düsseldorf, Duisburg, Frankfurt, and Stuttgart. These exports were the undertaking of the Chinese Landscape Architecture Company (Zhongguo yuanlin jianshe gongsi), a state corporation, and were designed in the vocabulary of the classical tradition. Appropriately, each garden and its contents were assigned Chinese names and verses, much like their counterparts in China.

To people interested in the Chinese garden, the sudden international popularity of the form was refreshing. Judging from the large number of new constructions completed in the 1980s and 1990s, and the anticipated growth in the future, some scholars speculate that the current development could rival, or perhaps surpass, the China-craze of the mid-seventeenth century, when a fashionable taste in Chinese gardens swept over large parts of Europe.

In China, as well, the classical tradition is thriving, despite the nation's passionate pursuit of modernization and Westernization in recent years. In the two decades that followed the signing of the Shanghai Communiqué by Premier Zhou Enlai and the American president Richard Nixon in 1972, a record number of new gardens were built in the traditional style around the country. Meanwhile, old private gardens and imperial parks were frequented by an unprecedented number of visitors, both local and foreign.

In Suzhou's Zhuozheng Yuan, for example, the total number of visits registered at the garden in 1985 was 2,610,800, almost six times the annual average recorded in statistics gathered between 1952 and 1972. At the same time, a seemingly inexhaustible curiosity about gardens has led to an outpouring of scholarly discoveries and publications in academic circles. Breaking new ground in theory and methods of design, these research productions have helped to bring the study of the classical Chinese garden to a new height. (Some of these publications are included in the Bibliography.)

The strength of the garden tradition has raised interesting questions about the nature of its artistic creation, as well as about its future role in an ever-changing world. For instance, one prominent Chinese scholar was confronted with the question: 'Why isn't the Chinese garden adopting the "international style" along with the trend of modernization in China?' He credited the enduring interest in the Chinese garden to the 'timelessness' of its formulation and its all-encompassing design principles. Using Astor Court as a case in point, he was able to present an analysis, elegantly and profitably, of this eighteenth-century imitation using the language of Charles Moore, Kurokawa Kisho, and Robert Venturi, the foremost design theoreticians of our time. Conversely, the writer argued, no comparable modern design theory has proven capable of producing the magic and charm of the age-old Chinese garden. The hallmarks of the post-modern movement are just a few design ideals among the many attributes implicit in the Chinese garden. In this sense, the Chinese garden already is and shall continue to be 'modern' in both spirit and form.

In an attempt to uncover the 'secrets' of the ancient masters, and to promote design efficacy in general, an intriguing study was conducted in 1984 at the University of California, Los Angeles. Its goal was to provide a more

5.2 A composite catalogue of the view-framing devices and scenery compositions of the Chinese garden. Courtesy Zhao Renguan.

systematic approach to the design of a Chinese garden (Zhao and Kvan, 1984: 8). Using a set of organizational rules extracted from existing gardens, a catalogue of compositional elements, and a list of view-framing devices described in the study, a designer is able to methodically compose a Chinese garden in the traditional convention with or without the use of a computer as a design aid (Fig. 5.2).

In the absence of greedy and fun-loving emperors, and without the active participation of the multi-talented yet emotional scholar–officials, today's new gardens are the products of professional landscape architects who, unlike their predecessors, do not have a vested interest and personal involvement in their creations. Whether the motivation behind their creation was nationalistic sentiment, a cultural awareness or curiosity, or as purely a business enterprise, the new generation of Chinese gardens appear 'heartless' and 'history-less' at best. Without an historical context and its intertwining socio-political and economic influences,

such as those of the Song and Ming dynasties, it is inconceivable that today's 'garden fever' will find a place in history as another climax along an evolutionary continuum that seemed to have ended abruptly during the late nineteenth century.

There are, however, also problems with the well-preserved classical gardens of China itself. First, there are concerns about the urban environment in which the gardens are situated. Most private gardens in Suzhou and Yangzhou, for example, are located in densely populated older districts of their cities. They are difficult to locate and access, and often appear as an 'oasis in a desert' amidst the worn-out and dusty urban fabric. In this regard, the recent urging of a leading Chinese scholar for a 'city-as-garden' approach in China's urban renewal efforts is most timely and encouraging. If and when the ideal is realized, Suzhou and Yangzhou would then be truly 'garden cities', instead of being merely cities with gardens.

Second, if the gardens of the past are viewed as 'a place where history is alive', then visitors today may find it difficult, if not impossible, to relive history in the gardens' current environment. Private gardens and imperial parks of yesteryear have, in effect, become 'people's gardens' and 'people's parks', particularly since the founding of the People's Republic of China in 1949. Encouraged by low admission fees and with more time for leisure, citizens on holidays have visited the petite and delicate gardens by the hundreds. Crowding, visual distraction, and acoustic pollution have become the norm in gardens and parks open to the public. At times damage to structures and rockeries have been reported as a result. It is most disappointing that quiet meditation and leisurely appreciation of nature are no longer possible today. The words of a distinguished writer on Chinese gardens are most revealing in her descrip-

tion of a typical garden tour of Suzhou's largest garden, Zhuozheng Yuan: 'Chinese and foreigners, old and young, they swarm over the Immortal's rocks, photograph each other on the bridges, and litter the lakes with a film of orange peel and cigarette ends... [T]he earth is stamped dry and lifeless by a thousand feet.... With so many people [in the garden] it is hard to know how best to preserve the balance between man and nature, already irreparably altered on our planet' (Ji, 1988: 25).

Keeping the balance is, perhaps, our greatest challenge. But in the wake of ongoing economic development, and the social mobility that results from it, authorities of garden bureaus find it increasingly difficult to manage the cultural heritage of a socialist country within a pseudo-capitalist economic system. Various options, however, are under consideration. Increasing the numbers of maintenance personnel, raising ticket prices, and perhaps even limiting the numbers of visitors at a given time are potentially workable solutions. With a goal to reach 11.0 square metres of green space per person in urban China by the year 2000 (the 1990 figure was 3.9 square metres per person), government authorities are pushing for more public parks and other lands for recreation. Such a move could alleviate some of the pressures from overcrowding and restore some of the desired tranquillity in small classical gardens.

Finally, the pressing issue of how to relate the past with the future, of mixing the old and the new, has become a national debate in China in the fields of architecture, landscape architecture, and planning. In design terms, the question, 'How can a garden of classical tradition be meaningfully incorporated into the environment for contemporary living?' is a new challenge for members of the garden design profession. Among the many responses to the scenario, one scheme stands out as exemplary.

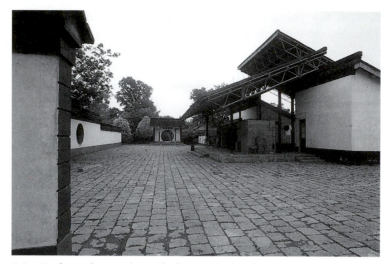

5.3 Traditional grey tiles and whitewashed walls adorn the lattice-beam and steel-post construction of the structures at the east gate of Fangta Yuan, Songjiang, Jiangsu province.

The design project referred to is the Fangta Yuan (Square pagoda garden), in Songjiang county, within Metropolitan Shanghai (Plate 19). Designed and built in 1981–4 by a team of architects and landscape architects from Tongji University in Shanghai, the large park of 11 hectares was built around three historical relics as its central theme. The three relics, a 900-year-old square pagoda of the Song dynasty, a Ming-dynasty screen wall built in 1370, and a Qing-period temple hall of an indefinite date, form a cluster in the centre of the site, which is surrounded by urban streets on all four sides. The primary design decision of the team was to use 'space' and 'time' to transcend the distance between historical China and modern-day Shanghai. Those garden structures nearest the three relics were designed to closely resemble the Song, Ming, or Qing styles. The degree of the 'classicism' of buildings becomes gradually diluted as the

distance increases from the trio. Accordingly, incorporating modern materials and technology the structures at the two main entrance gates along the perimeter streets look shockingly 'post-modern'. Yet, the traditional grey tiles and whitewashed walls that adorn the lattice-beam and steel-post construction serve as reminders of the garden's cultural origin (Fig. 5.3).

'Space' serves as a buffer zone between the ancient relics and the modern metropolis, and 'time' provides a temporal passage through which the ancient pagoda, the sculptured screen wall, and the temple hall are visually explored along with the other scenic elements of the garden. The quote of a contemporary theoretician can best describe the underlying significance of the Fangta Yuan: 'We ought to affirm such an exploration when dealing with the contradiction of a historical site with a modern society, including its everyday life, its updated technology, and its psychological acceptability.... [S]uch a pioneering example does encourage us to think of further deviation from the above-mentioned one-axis structure of current Chinese architecture, so as to face the challenge of world architectural development' (Li, 1991, 50).

'Exploration' seems to be the answer to the dilemma confronting China's new generation of garden designers. In their current and future efforts, more experimentation, rather than merely imitation of the past, is needed. In this sense, the design of the Fangta Yuan is exemplary.

Selected Bibliography

Sources in the Chinese Language

An Huaiqi (1991), *Zhongguo yuanlin shi* (A History of Chinese landscape gardens), Shanghai: Tongji Daxue chubanshe.

Chen Congzhou (1984), *Shuo yuan* (On Chinese gardens), Shanghai: Tongji Daxue chubanshe.

Cheng Liyao (1992a), *Wenren yuanlin* (Scholar's garden), Taipei: Guanfu shuju.

Cheng Liyao (1992b), *Huangjia yuanyou* (Imperial parks), Taipei: Guanfu shuju.

Ji Cheng (1932), *Yuan ye* (A Garden design manual), Beiping: Zhongguo yingzao xueshe.

Li Yu (Liweng)(1995), *Xian qing ou ji* (The Art of living), Beijing: Zuojia chubanshe.

Pan Guxi (1988), *Zhongguo meishu quanji—3: Yuanlin jianzhu* (A Complete collection of Chinese art—Book 3: Garden architecture), Beijing: Jianzhu gongye chubanshe.

Peng Yigan (1986), *Zhongguo gudian yuanlin fenshie* (An Analysis of Chinese classical gardens), Beijing: Jianzhu gongye chubanshe.

Sun Xiaoxiang (1982), 'Jiangsu wenren xieyi shanshui pai yuanlin', (Scholar's landscape gardens of Jiangsu province), in *Linye shi yuanlin shi lunwen ji* (Essays on the history of forestry and gardens), Beijing: Linxueyuan.

Yang Hongxun (1988), 'Lue lun Zhongguo Jiangnan gudian zaoyuan yishu' (A Brief discussion on the art of gardening in China's Southern Yangzi river delta), in *Jianzhu shi lunwen ji* (Essays on the history of architecture) #10, Beijing: Qinghua Daxue chubanshe.

SELECTED BIBLIOGRAPHY

Zhang Jiaji (1986), *Zhongguo zaoyuan shi* (A History of Chinese garden-building), Harbin: Heilongjiang renmin chubanshe.

Zhang Jiaji (1991), *Zhongguo zaoyuan lun* (A Discourse on Chinese Garden Building), Taiyuan: Shanxi renmin chubanshe.

Sources in the English Language

Chang, Kang-i Sun (1986), *Six Dynasties Poetry*, Princeton: Princeton University Press.

Cheng Liyao (1995), 'On Chinese Gardens', translated by Joseph C. Wang. An address delivered at the conference, 'Sir William Chambers und der English-chinesische Garten in Europa', Oranienbaum, Germany, 4–7 October.

Clunas, Craig (1996), *Fruitful Sites: Garden Culture in Ming Dynasty China*, Durham, NC: Duke University Press.

Egan, Ronald C. (1984), *The Literary Works of Ou-yang Hsiu (1007–72)*, Cambridge: Cambridge University Press.

Engel, David H. (1986), *Creating a Chinese Garden*, Portland: Timber Press.

Institute of the History of Natural Sciences, Chinese Academy of Sciences (1986), *History and Development of Ancient Chinese Architecture*, Beijing: Science Press.

Ji Cheng (1988), *The Craft of Gardens*, translated by Alison Hardie, New Haven: Yale University Press.

Johnston, R. Stewart (1991), *Scholar Gardens of China*, Cambridge: Cambridge University Press.

Keswick, Maggie (1978), *The Chinese Garden: History, Art and Architecture*, New York: Rizzoli.

Kwong, Charles Yim-tze (1994), *Tao Qian and the Chinese Poetic Tradition*, Ann Arbor: Center for Chinese Studies, University of Michigan.

Li, Daxia (1991), 'Current Chinese Architecture', *Habitat International* 15(3): 43–50.

69

Lin Yutang (1935), *My Country and My People*, New York: John Day.

Lin Yutang (1937), *The Importance of Living*, New York: John Day.

Liu Dunzhen (1993), *Chinese Classical Gardens of Suzhou*, translated and edited by Joseph C. Wang, Beijing: China Architecture and Building Press.

Murck, Alfreda, and Wen C. Fong (eds.)(1991), *Words and Images: Chinese Poetry, Calligraphy, and Painting*, Princeton: Princeton University Press.

Tsu, Frances Y. (1988), *Landscape Design in Chinese Gardens*, New York: McGraw-Hill.

Wong Young-tsu (1997), *A Paradise Lost: An Inquiry into Imperial Gardens Yuanming Yuan*, unpublished manuscript.

Zhao Renguan, and Thomas Kvan (1984), 'The Gardens of Suzhou: An Analysis of the Principles of Chinese Garden Design', in *BUILT* 2(1), Graduate School of Architecture and Urban Planning, University of California, Los Angeles.

Index

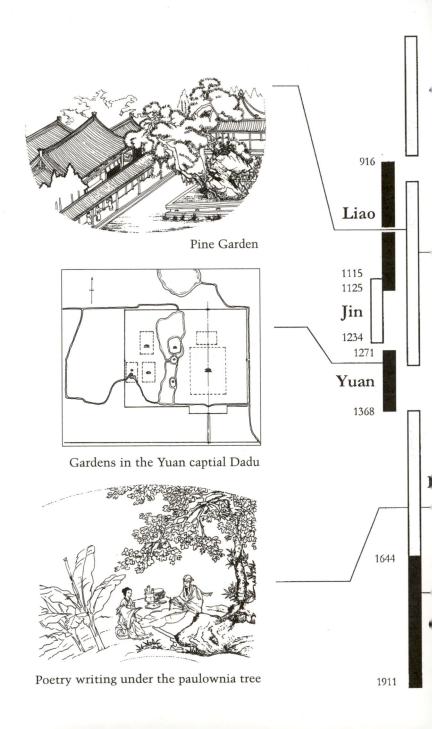

Pine Garden

Gardens in the Yuan captial Dadu

Poetry writing under the paulownia tree

916

Liao

1115
1125

Jin

1234
1271

Yuan

1368

1644

1911